\mathscr{A} HISTORY
T H R O U G H
HOUSES

\mathscr{A} HISTORY THROUGH HOUSES

Cape Cod's Varied Residential Architecture

PAGe 74/75
81

JACI CONRY

Charleston London
THE
History
PRESS

Published by The History Press
Charleston, SC 29403
www.historypress.net

Front cover, clockwise from top left: by Randall Perry, courtesy of Polhemus DaSilva Architects
Builders; by Christopher Seufert; by Brian Vanden Brink.
Back cover, clockwise from top left: courtesy of the Historic Highfield, Inc. Collection; by Paul
Rocheleau, courtesy of Polhemus DaSilva Architects Builders; by Randall Perry, courtesy of
Polhemus DaSilva Architects Builders.

First published 2010

Manufactured in the United States
ISBN 978.1.59629.999.3

Library of Congress Cataloging-in-Publication Data
Conry, Jaci.
A history through houses : Cape Cod's varied residential architecture / Jaci Conry.
p. cm.
Includes bibliographical references and index.
ISBN 978-1-59629-999-3
1. Architecture, Domestic--Massachusetts--Cape Cod. I. Title. II. Title: Cape Cod's varied
residential architecture.
NA7235.M42C3736 2010
728.09744'92--dc22
2010020919

For my parents, who inspired me to love historic houses.

CONTENTS

Acknowledgements 9

Introduction 11

1. The Region's Earliest Dwellings: The Enduring
 Cape Cod–Style House 19
2. The Whaling Era: Georgians, Greek Revivals and
 Second Empires 39
3. Camp Revivals and Carpenter Gothic Architecture 61
4. Cape Cod's Golden Age 77
5. Embracing the Twentieth Century 101
6. Modernist Residences 115
7. Houses of Contemporary Times 129
8. Where to Go 145

Bibliography 153
Index 155
About the Author 159

ACKNOWLEDGEMENTS

This book would not have come together had it not been for a variety of individuals who encouraged and assisted me along the way. First and foremost, I thank my editor at The History Press, Jeff Saraceno, who believed in my idea for this book. I am grateful to several photographers who went out of their way to make images available to me, including Dan Cutrona, Bill Lyons and Christopher Seufert. Director of the Cape Cod Modern House Trust, Peter McMahon, made sure I had images of the Outer Cape's Modernist houses, and the folks at Highfield Hall graciously gave me access to their archival photos.

I am grateful to John DaSilva for allowing me to print images of his firm Polhemus DaSilva Architects Builders' stunning projects and for sharing his thoughts about Cape Cod's residential architecture. Sara Porter, also an architect, provided valuable insight on the topic as well. Several historical societies provided me with valuable resources, and among the most helpful were the Brewster Historical Society, the Falmouth Historical Society, the Historical Society of Old Yarmouth and the Woods Hole Historical Society.

I thank my mother—a talented journalist in her own right—for encouraging all of my writing endeavors over the years and for being an objective editor on this book; and my dad, from whom I learned

about perseverance and how rewarding restoring an old house can be. Most importantly, I thank my husband, Mike, whose support, generosity and patience made it possible for me to write this book in an intensely short time frame. Because I have him in my life, all things seem possible.

INTRODUCTION

I think lots of us tend to look back on the homes where we grew up with nostalgia, recalling memories and reliving the past. Looking back, it sometimes seems we love a place even more after we've left it.

The house I grew up in was a stately Greek Revival built in 1840. Sided with neat white clapboards, the house had black shutters, seven steep gables and a front porch with delicately detailed pilasters that was long and very narrow, just wide enough to accommodate a wicker sofa and two rocking chairs. The house, with its symmetrical shape and generous double-hung six-over-six pane windows, was built for a sea captain named Charles Davis during the early days of the whaling era.

Several other sea captains and members of Captain Davis's family built similar homes in the neighborhood, which became known as Davisville. The house was located a half-mile from the ocean in Falmouth, a Cape Cod town with sixty-eight miles of shoreline along Vineyard Sound and Buzzards Bay where, during the nineteenth century, many men made their living on the sea.

I loved that house from the minute my family moved in during the early 1980s. The house rambled with spacious, high-ceilinged rooms, some of which adjoined others. There was a hidden staircase. Closets had funny shapes: some were nothing more than a shallow band of shelves, while others were deep and dark, tucked under gables. The house had

four chimneys and five fireplaces, including one in my room. Though the hearth had been sealed shut to prevent heat loss, the fireplace had a prominent mantel that I was especially proud of.

After Davis—a man I imagined having a handlebar mustache, potbelly and a pipe forever sticking out the side of his mouth—passed on, the Bakers moved in. They ran a dairy farm on the property. The farm's hub was a big red barn with several rooms and two levels, with nooks and crannies that I was endlessly investigating.

Oh, how I imagined the past, wondering what a girl my age would have done on the property more than a century earlier. I envisioned the backyard with the flower gardens—which my mother so carefully tended to—and the vast lawn—which my father spent a good part of every summer weekend mowing—as pasture where cows and horses grazed. It thrilled me to think that my home had once been the center of such activity.

While Davis built the house with riches garnered on his far-flung whaling voyages, by the time my family moved in, the house was far from the grand place it had probably been considered during the nineteenth century. Hallways were narrow, the wide plank wood floors creaked and the central staircase was so steep I tumbled down it more than once as I attempted to take the stairs too quickly. The house, with its horsehair plaster walls, was drafty on winter nights and humid in the summer. Most of the antique windows couldn't stay open on their own, needing to be propped open with miscellaneous household items: books, rulers or coffee cans.

Our house was different from my friends' newer contemporary homes. Sure, I was envious at times of their wall-to-wall carpeting, their more modernized bathrooms, expansive back decks and finished basements—our cellar was a small, round room with brick walls and a dirt floor, with scarcely more than a ladder to access it.

But my house had something theirs didn't: it had history. In it, I found the edges and corners of the past. While I discovered artifacts, including old coins, antique buttons and yellowed newspapers from the 1800s, much of the evidence of other eras—of the different lives lived in the house— came from the layers of wallpaper and paint, nicks in the woodwork and

scratches on the window glass. Even the earth surrounding the house yielded up evidence in the form of marbles, old hinges and large cow bones. A photo taken after the Civil War shows two horse chestnut trees in the front yard as recently planted saplings. By the time I lived there those trees, whose branches I climbed and swung from, were taller than the house. That photo fascinated me; the trees reminded me that we were not the first to live in the house, nor would we be the last.

Following the Davises and the Bakers, two other families lived in the house before my family bought it. Over the years, the house grew, an ell was added to the back, the kitchen was enlarged and another wing was put in upstairs. Unsympathetic renovations made during the 1950s and 1960s had affected the home's historic integrity. When my family moved in, my parents made a commitment to restore it. In particular, my father's devotion to the house inspired me. An attorney who in another life might have been a carpenter, he spent his weekends laboring over the house. He, often with my mother at his side, did demolition, removed cabinets and tore down walls. He replastered and painted, stripped, sanded and stained floors, built a new hallway and removed the living room's drop ceiling to reveal original hand-hewn beams. He repaired the porch, refinished countless old doors, replaced glass windowpanes and built a lovely brick patio in one weekend. During my childhood, there was always a project going on. There were times we lived with a layer of dust on everything for months. But after each project was completed, the house gleamed a little brighter, and our connection to it was deeper.

Thirty years later, my parents still live there; their devotion to it is as strong as ever. Indeed, the house cultivated my love of historic architecture. My experience living in that gracious Greek Revival with its creaky floors taught me to realize the stories that houses can tell us—what they can reveal or lead us to surmise about prior inhabitants and the eras of the past. I can't help but notice historic homes on the streets of Cape Cod. I'll slow as I pass them, taking in their exterior details, looking for clues about their origins, imagining what the circumstances were when they were built.

Old houses cause us to consider the past, to look back while moving forward with our lives. The way houses were built, the materials they

consist of, details of moldings and staircases, front entryways, roof pitches, shutters, paint colors and window fenestration all account for something. There were reasons and influences behind these choices. This book attempts to identify and explore them.

It is my fascination with and curiosity about historic architecture, combined with Cape Cod's wealth of historic houses, that led to this book. Abundant as it is, the region's historic architecture is under-appreciated. It is well known, even to people who have never been to this sandy peninsula, that the Cape is quite a pretty place, astounding even, with its broad white sand beaches, serene salt marshes and bucolic village greens. Tiny shacks line old country roads, and sea grass rustles with the ocean breeze. Named Cape Cod by the English explorer Bartholomew Gosnold for the vast schools of codfish he found in the waters surrounding the land, the Cape's timeless landscape has been appreciated since Henry David Thoreau first wrote about it in 1860. The region's residential architecture, however, has been somewhat under the radar.

Cape Cod has a rich vernacular heritage, an array of eclectic and intriguing architecture that represents the region's different eras. From Provincetown at the northern tip to the village of Woods Hole all the way at the other end, the houses of Cape Cod encompass an extensive range of styles. The book's first chapter depicts the region's original spare and functional one-and-a-half-story houses built between the mid-seventeenth century and the early nineteenth century and later coined the "Cape Cod" style. The earliest settlers, a simple, hardworking folk, constructed the weathered gray homes with steeply pitched roofs out of massive hewn oak timbers using the post-and-beam method. Houses, anchored by large central chimneys, were intended to be basic shelters with few rooms and devoid of ornamentation—inhabitants were not concerned with impressing their neighbors.

In the next chapter, the Cape's transition from a desolate enclave to a prosperous maritime community in the mid-nineteenth century is explored. It was an era of optimism and wealth, and successful whaling ship captains and merchants built stately homes as testaments to their affluence. Unlike the prior era's Cape Cod–style houses, these homes—Georgians, Greek Revivals, French Second Empires—were intended to

draw attention to themselves with graceful exterior details, including front doors with filigreed fanlights, intricate porticos and towers. The interiors were designed to offer residents comfort and to showcase high-class furnishings collected on the captains' voyages to exotic locales. This new style involved new concepts of living for Cape Cod residents. Multiplication of rooms led to increased specialization; there were separate rooms for sleeping, cooking, dining and socializing.

Among the assortment of homes built during the nineteenth century were Carpenter Gothic cottages built by Methodist camp-goers who attended annual summer religious revivals at various Cape Cod locales. Heavily influenced by Victorian architecture and a variant of the Gothic Revival style, Carpenter Gothic design, detailed in Chapter 3, emphasized verticality and was characterized by scrolled ornaments, lacy "gingerbread" trim and unique jigsaw decorations. Intended to be seasonal homes, these cottages were harmonious with the purposes of the camp meetings. They seemed almost religious in nature. With a chapel-like appearance, they appeared to be tiny churches. As time went on, the cottages became increasingly colorful and whimsical. Eventually, the Carpenter Gothic style, along with the similar but more mature Gothic Revival style, became prevalent beyond campgrounds in other areas of the Cape.

Train travel made Cape Cod a much more accessible destination. By the time rail service was available in most of the region's towns in the 1870s, Cape Cod had begun to evolve into a summer resort for the well-to-do. Throughout the late nineteenth and early twentieth centuries, affluent businessmen from Boston and New York took advantage of the prospering economy and built lavish summer estates for their families. Chapter 4 depicts the architecture of the "golden age," an era when mansions were built in large measure. The structures represented a variety of styles—Italianate, English-style country manors, Shingle style and Queen Anne. The houses were of grand scale and design, intended not only to provide a relaxing summer respite for the families who owned them but also to be showplaces worthy of high-class entertaining. Many mansions were designed by lauded architects and were equipped with the era's most modern conveniences: electricity, plumbing, gas heating and

elevators, along with billiard rooms and art galleries. Interiors had rich details, hand-carved mantels and moldings, and materials were of the highest quality: marble fireplace surrounds, imported wood paneling, gilt lighting fixtures. Laid out on expansive grounds, these houses had rolling lawns and ornamental gardens.

About the turn of the twentieth century, summer painting colonies began sprouting up on the Outer Cape, primarily in Provincetown, which evolved into a bustling art community, luring creative types from all over the country. Artists, writers, poets and playwrights flocked to the area seeking inspiration and both camaraderie and solitude. Chapter 5 provides a sharp contrast to the previous chapter's depiction of the region's opulent mansions with insight about the rustic shacks interspersed among the dunes of Provincetown near the Peaked Hill Bars Life Saving Station that many writers and artists took to inhabiting starting in the 1920s. The shacks, situated along a three-mile stretch of incredible dunes anchored by a thin layer of beach grass from Race Point to High Head in Truro, were first built in the 1800s by the Humane Society in conjunction with lifesaving efforts. By the 1920s and 1930s, when noted creatives—including Eugene O'Neill, Jackson Pollack and e.e. cummings—took to the dunes, shacks varied slightly in size and design, but all were rustic and weathered, devoid of electricity, running water and toilets, with no modern conveniences whatsoever. That would not change over the ensuing decades.

The years following World War II represented an important architectural era on the Outer Cape. In the 1940s and 1950s, the area attracted acclaimed Modernist European architects who had made their way to the United States, including Marcel Breuer, Serge Chermayeff, Paul Weidlinger and Olav Hammarstrom. The architects built summer cottages in the area, discovering that the Cape was an ideal place to experiment with their designs. They were enticed by the region's pristine environment and undeveloped land that was available for modest sums. The small houses they built, which tended to be of cubic shapes with flat roofs, were humble in budget, materials and environmental impact. They were airy and informal, with few frills, exemplifying the concept that a lot of material things were not necessary to live happily.

Chapter 7 takes a look at the Cape's present-day residential architecture, at the forms houses have taken over the last several decades. Architects offer insight about how homes built in recent years have been influenced by historic styles as well as how they have embraced innovative design techniques, elements and materials. Additionally, the chapter examines the various reasons why and how people build homes on Cape Cod today. It also addresses the current state of historic residential architecture: how it can be preserved while making structures comfortable for contemporary living.

Finally, the last chapter of the book serves as a guide to be used by those who are interested in seeing some of the region's examples of historic architecture, identifying various houses that are open to the public as museums and pinpointing areas worth seeking out.

Architecture is an eloquent expression of who we are. It depicts our history. What we build is as revealing as the stories we write or the legislation we pass. Indeed, the regional vernacular of Cape Cod, from its seventeenth-century origins throughout the following centuries, tells the story of a rare and wonderful community that has experienced significant cultural changes. Once a desolate enclave inhabited by farmers, Cape Cod became a hub for maritime activity and evolved into a wealthy summer playground, attracting seafarers, artists, religious types and modern innovators at various points along the way. The diverse expression of house styles found along Cape Cod's main thoroughfares and winding back roads reminds us of the region's evolution and also helps us to understand the influences of the different eras and to imagine what the lives of those who lived here long ago might have been like.

Chapter 1

THE REGION'S EARLIEST DWELLINGS

THE ENDURING CAPE COD–STYLE HOUSE

A DESIGN EVOLVES

The simple one-and-a-half-story form of the Cape Cod–style house is part of our present-day architectural vocabulary, thanks to Reverend Timothy Dwight, president of Yale University from 1795 to 1817, who coined the term "Cape Cod House" after a visit to Cape Cod in 1800. In his book *Travels in New England and New York*, he observed that the small homes that dotted the Cape from Bourne to Provincetown were so much of a pattern that they constituted a "class which may be called, with propriety, Cape Cod houses."

Dwight noted that the houses

> *had one story and four rooms on the lower floor; and are covered on the sides, as well as the roofs, with pine shingles, eighteen inches in length. The chimney is in the middle behind the front door…the roof is straight…A great proportion of them are in good repair. Generally, they exhibit a tidy, neat aspect in themselves, and their appendages; and furnish proofs of comfortable living, by which I was at once disappointed, and gratified.*

The first settlers to Cape Cod were farmers, fishermen, carpenters and shipwrights. These early colonists put down roots on the sandy

peninsula during the seventeenth century. By 1644, the towns of Sandwich, Barnstable, Eastham and Yarmouth had been established. Over the next decades, Falmouth, Harwich, Mashpee, Orleans and Provincetown would be settled; the Cape's remaining six towns— Bourne, Brewster, Chatham, Dennis, Truro and Wellfleet—would be established over the next one hundred years.

Early Cape residents were a modest people, and simplicity was the hallmark of the architecture. Houses had low eaves, no cornices and a six-paneled front door flush with the lintel (a supporting wood or stone beam across the top of an opening). They were essentially compact one-and-a-half-story rectangular boxes that were slightly wider across the front than they were deep. Houses were reminiscent in snugness of a ship's cabin and had one central chimney and steep gabled roofs composed of two slopes with no breaks or valleys. Exhibiting an almost austere quality, Capes were neat, trim and durable. Owners

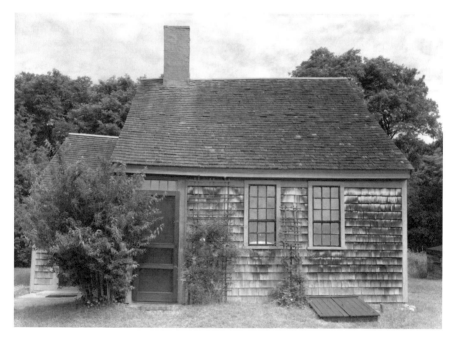

Rowell House, a 1731 "half house" in Wellfleet that is likely the oldest house in town and certainly the most archaic type. *Photo by Cervin Robinson.*

weren't interested in impressing or competing with their neighbors, and houses were absent of ornamentation. There were no porches or columns; the only decorative highlight was the front door, which was often carved or fluted.

AFFORDABLE, STURDY CONSTRUCTION

In the 1700s, houses cost between $100 and $200 to build, a sum that most working classes could afford. Since stone was not available, the long-lasting structures were built of wood, which was abundant as the virgin oak and pine forests had yet to be harvested. Homes were constructed of timber and planks and covered with shingles, which were left to weather in the salt air to a natural silvery grey. Using the post-and-beam method, framing was assembled with massive oak timbers joined not by nails but by intricate wood joints secured with stout oak pegs. Wide oak plank floors (from twelve to twenty inches wide) were laid on runners placed on the ground, and vertical pine boards formed the inside wall surface; corner constructional supports were often exposed.

These early structures were built inland, where the soil was less sandy and more fertile for farming. Another benefit to building away from the coastline was that there was more protection from the Nor'easters that shook the shores of the Atlantic. Yet the relentless sea winds were felt across the entire region, so the earliest Capes were built low to the ground to ride out the wind, rain, blizzards and occasional hurricane. Since the houses were set so close to the ground and had minimal vertical surfaces, a low pitched roof and virtually no projections, the house could ride out storms that might have flattened taller, more elaborate homes.

A massive chimney block, set dead center within the house opposite the front door, dictated placement of the rooms. The chimney acted as an anchor to hold the dwelling on its base, to secure the house against the gales. While many early houses throughout New England had stone or brick foundations, the early Capes, built from the mid-1600s through the early 1800s, had no foundations. They rested upon huge, hand-hewn oak timbers supported on piles of rocks or laid directly upon

the land, which acted as a natural blotter for moisture and storm-high water. This reduced construction costs and saved on scavenging for materials, as owners only needed expensive bricks and scarce stones for fireplaces and chimneys.

Variations of the Style

The Cape Cod house had three variants that all likely appeared around the same period. The half house, sometimes called "the house," had two windows to one side of the door. The starter house of its day, the half house typically morphed into a three-quarter Cape and on to a full Cape as family size and income increased. The three-quarter house, sometimes called "house-and-a-half," had two windows to one side of the door and one to the other. Probably the most common of eighteenth- and

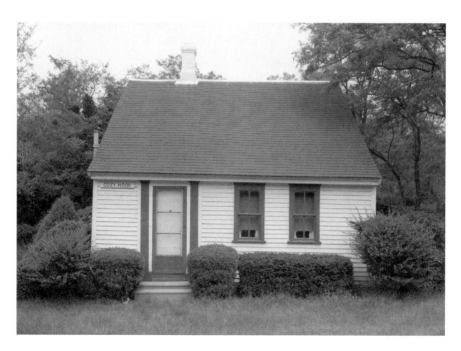

Benjamin S. Kelley House, a very early "half house" with a three-bay front, a door on the west and a two-window room on the east, located within the Cape Cod National Seashore in Truro. *Photo by Cervin Robinson.*

The Region's Earliest Dwellings

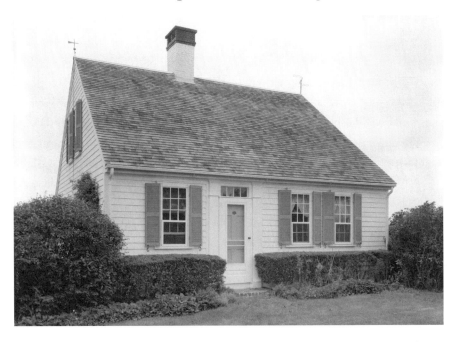

Ephriam Harding House, a four-bay "house-and-a-half" built in Truro in 1823. *Photo by Cervin Robinson.*

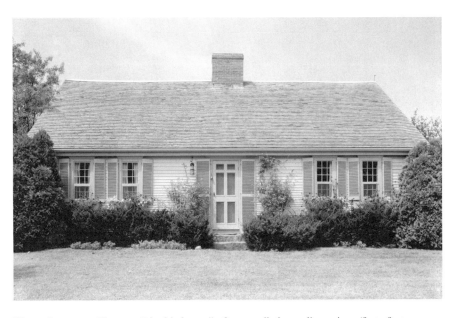

Howes Jorgenson House, a "double house" of unusually large dimensions (forty feet across the front). When it was built in Dennis in 1766, it was one of the finest houses in town. *Photo by Cervin Robinson.*

nineteenth-century Cape Cod architecture, the house had four bays, and the entry was offset slightly from the chimney. The full Cape, referred to as a "double house," had a door in the center flanked by two windows on either side. A rarity in the eighteenth century, full Capes, with their symmetrical five-bay façades and generous entrance doors centered on the chimney, belonged to only the most successful settlers. No matter the variation, the Cape Cod house always followed the same basic floor plan.

Layout and Room Use

Early Capes were as uniform throughout the interior as they were on the outside, and the house played the trick of being more spacious than it appeared. Houses typically contained four rooms, which were used for multiple purposes. The layout consisted of a hall and three main

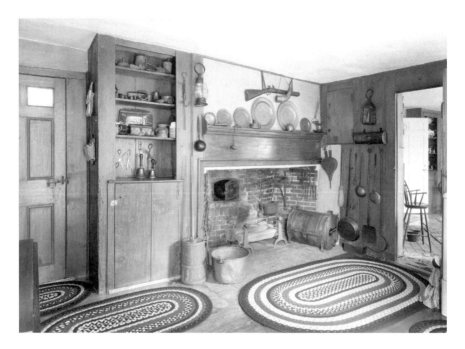

Keeping room of Wellfleet's Atwood Higgins House, a "half house" built in the early eighteenth century that was expanded in the nineteenth century to a "double house." *Photo by Cervin Robinson.*

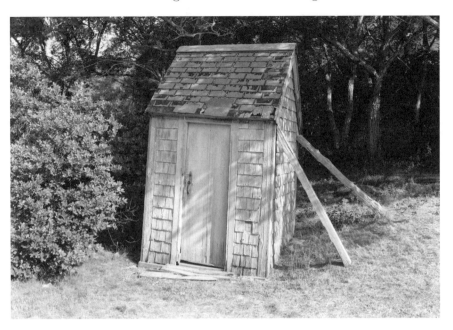

An early nineteenth century privy constructed of weathered shingles, with a plank door and a wrought-iron door latch. The leaning structure is propped up by two timbers on one side. *Photo by Cervin Robinson.*

rooms on the ground floor; a large rectangular room at the rear was the predecessor of the combined family room and kitchen we build today. Known as the keeping room, it served as the cooking room, living area and workshop. A sturdy table occupied the center of the room, where eating, weaving, sewing and furniture making took place. The room typically had a mammoth fireplace—sometimes big enough for an adult woman to step into without stooping—with a beehive oven, where temperatures could reach seven hundred degrees. An outside door at the back or side led to the well, privy, garden and outbuildings.

One of two smaller square rooms off the keeping room was the buttery, where food, dishes and other household items were kept and where milk was separated and butter was churned. Below the buttery, a trapdoor often led to a circular "Cape Cod" cellar, where vegetables were stored in the winter and perishables were kept cool during the summer. Cellar construction required a minimum of material, requiring neither massive stones nor bonding of brick. Walled with a single layer of brick, the

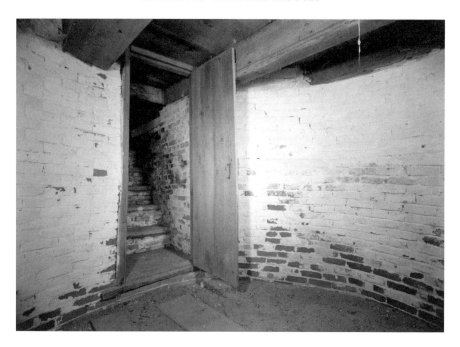

Example of a late eighteenth century Cape Cod cellar. Walled with a single layer of brick, walls were round to withstand the pressure of surrounding soil. *Photo by Cervin Robinson.*

cellar, less than twelve feet across, was round to withstand the pressure of the surrounding soil.

The second room was the borning room, which, true to its name, was where babies were born. It was also where babies were nurtured, as they could be close to their hardworking mothers, and where the sick or infirm members of the family would be housed. Many houses had an additional small square parlor in the front, next to the hall where guests were received. As it was the room reserved for special occasions—weddings, funerals, visits from clergy—it was usually the most carefully finished room in the house. It was furnished with the best furniture, including a bed, and often the fireplace was paneled and wainscoting was used around the room.

The unfinished attics were utilized as sleeping quarters. The stairway to the second floor was frequently about as steep as a ship's companionway. Stairs were located in the kitchen, where they were sealed off by a wall and a door to prevent heat loss from the room. In other instances, the

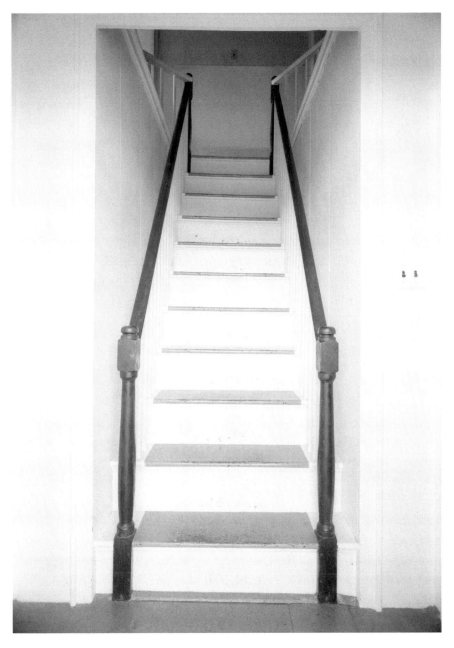

The "good morning" staircase of the Jonah Atkins House, an early nineteenth century "double house." *Photo by Cervin Robinson.*

stairs were dead ahead of the front door. When the flight of steep stairs from the front hall reached the chimney block, it stopped at a tiny landing and a couple more steps turned both right and left, serving both attic chambers. Early settlers affectionately coined the narrow stairwells "Good Morning Stairs," a moniker that stemmed from the fact that as family members who slept upstairs arose, they met on opposite sides of the landing and greeted one another with a cheery "good morning" before descending to the first floor.

As with the exterior of the houses, decorative interior flourishes were minimal. Wide oak floorboards were left unfinished and kept neat by scrubbing with sand. Since small windows brought in minimal light, interior walls were whitewashed to brighten the rooms. To add character, stenciling was occasionally done along the upper part of the walls. Color was introduced to rooms with braided or woven rugs or canvas floor cloths, and soft pine furniture was livened up and protected against scarring with bright paint.

Keeping the Chill Out

Each room on the main level had a fireplace, and rooms were compact because fireplaces could not heat large areas. Fireplaces had simple, classic wooded mantels, or none at all, and built-in wooden cupboards were typically recessed in vertically paneled walls next to the fireplace. Most houses faced south so the sun added warmth to the front rooms. To conserve heat, doorways were placed close under the eaves and were shorter than they are today, six feet high or less. Ceilings were low as well, measuring about seven feet high. It was necessary to block fireplace openings with fireboards; otherwise, since early fireplaces did not have dampers, heat was sucked from the rooms up the massive one-flue chimney in enormous volume. The keeping room, however, was kept reasonably warm all the time because the fire in the expansive fireplace was never extinguished.

While strong wood for the roof and walls provided a barrier against the cold, houses had little or no insulation, and when they were insulated, it

consisted of seaweed stuffed between two layers of paper. In many cases, walls without insulation were applied directly to the exterior sheathing. This meant that walls were only about three inches thick. To fill in chinks around sill joints and wall frames, mortar made of burned clam and oyster shells was used. In some areas, old sails were stretched, nailed to the floor and painted to keep out the dank chill seeping up from the sandy soil.

Windows were small with multiple panes, generally with nine six- or eight-inch rectangular lights in the upper sash, which did not slide, and six in the lower sash; another variation was twelve over eight lights or eight over twelve. Frames were thin and delicate. Window sashes and frames, as well as siding and exterior doors, were treated with fish oil, an early preservative; however, this didn't necessarily prevent the earliest structures from rotting. Shutters were often on the inside of the house, where the occupants could close them without stepping outdoors. Widespread use of exterior shutters did not occur until the late eighteenth century.

DISTINCTIVE ROOFLINES

Perhaps the most defining feature of the original Cape Cod house was the dormerless roof. Early Capes often appeared to be mainly roof—the roof-to-front ratio was roughly 60 to 40. While the roof steepness depended on the size of the house it sheltered, it formed a ninety-degree angle at the ridge. A "short hoist and a long peak" was the native description for a cottage contour designed to snuggle close to the landscape and resist the relentless force of sea winds. A steep, perfectly pitched roof had a range of eight to twelve inches per horizontal foot. Roofs were shingled with long pine "shakes" and, later, with red cedar shingles left to weather. These were applied directly over vertically laid boards and overlapped to a thickness of four or five layers, creating an impervious, easily repairable covering.

The roofs had gables to the sides and no dormers, so the sleeping chambers depended on windows in the gable ends for light and ventilation. Typically, two large windows in the middle of a gable were flanked by

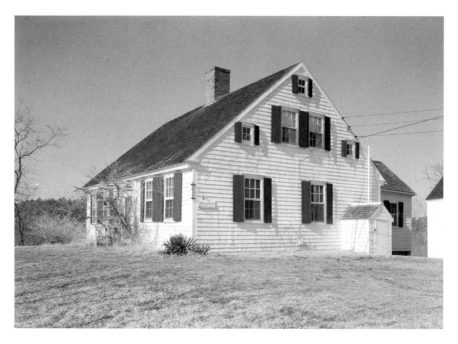

Detail of the second-story window configuration of the John Newcomb House in Wellfleet. *Photo by Cervin Robinson.*

two very small windows and a fifth, very small window at the peak for ventilation. Yet many houses had anywhere from one to four windows, and in some cases, the tiny windows were triangular. The windows often gave the simple houses unique character. When he traveled throughout Cape Cod in the nineteenth century, these windows appealed to Henry David Thoreau. After a walk along Nauset beach in 1849, he observed

> *two or three sober-looking houses within half a mile, uncommonly near the eastern coast. Their garrets were apparently so full of chambers that they could hardly lie down straight and we did not doubt that there was room for us there. Houses near the seas are generally low and broad. These were a story and a half high; but if you merely counted the windows in their gable ends, you would think that there were many stories more, or, at any rate, that the half-story was the only one thought worthy of being illustrated.*
>
> *The great number of windows in the ends of the houses, and their irregularity in size and position, here and elsewhere on the Cape, struck*

us agreeably—as if each of the various occupants had punched a hole where his necessities required it and according to his size and stature, without regard to outside effect. There were windows for grown folks, and windows for the children—three or four apiece; as a certain man had a large hole cut in his barn-door for the cat, and another smaller one for the kitten. Sometimes they were so low under the eaves that I thought they must have perforated the plate beam for another apartment, and I noticed some which were triangular to fit that part more exactly.

He also added suspiciously that the windows must have served as "so many peep holes that a traveler has small chance with them."

As family size increased, attics no longer offered enough sleeping space, so some Cape Cod builders took to building bowed roofs, an evolution of the pitched roof, to create an attic with more useable space. Bowed roofs, also known as rainbow roofs and ship's bottom

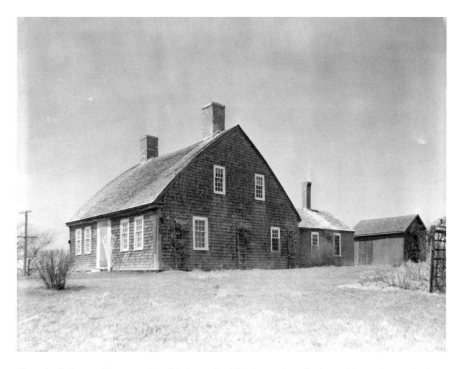

Captain Solomon House, a "double house" with a bowed roof adapted from the methods used in shaping the hull of a ship. *Photo by Arthur C. Haskell.*

roofs, were adapted from the methods used in shaping the hull of a ship. To achieve the graceful curve of a bowed roof, green timbers were laid over a rock and weighted down at the end. As the wood seasoned, or dried, an arc was formed. Since the bow gave the form of an arc—an inherently strong form—and pre-stressed it against its own weight and the weight of winter snow, while other roofs sagged after a few decades, bowed roofs stayed sturdy for centuries. While it may seem to be a lot of effort to go to to achieve a few extra inches of headroom, the bowed roof indeed added a handsome element to the subtly designed house.

A less utilized third roof variation, the gambrel, was constructed on some Capes. Unlike the bowed roof, it provided an almost full second story while maintaining all other features of a Cape Cod house. The gambrel also required shorter timbers, which were more readily available than a gable roof. In Chatham, the Atwood House, former home of sea

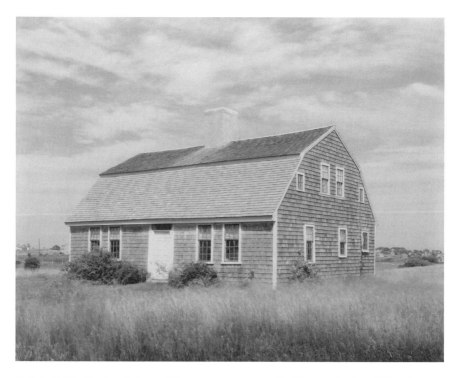

Built in 1752, Chatham's Atwood House was constructed with a gambrel roof. *Photo by Arthur C. Haskell.*

The Region's Earliest Dwellings

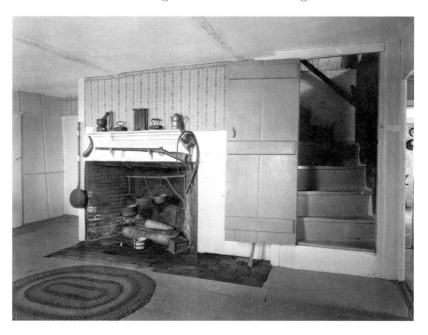

The keeping room of the Atwood House contained a central cooking hearth and stairs to the attic. *Photo by Arthur C. Haskell.*

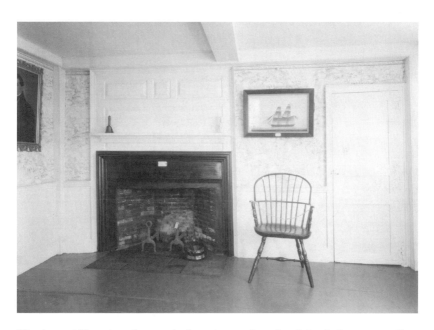

The Atwood House's parlor was the home's most formal and detailed room; paneling surrounded the fireplace, and wallpaper—likely a nineteenth-century addition—graces the walls. *Photo by Arthur C. Haskell.*

33

captain Joseph Atwood, is an example of a Cape with a gambrel roof. Built in 1752, it is now open to the public as a museum operated by the Chatham Historical Society. Restored and furnished to reflect several periods, the house has an intact keeping room, a borning room and a parlor, along with a large open attic featuring a finished bedroom and a fireplace, a rarity of the era. A wing was added in 1833 to include a new kitchen with a cast-iron stove.

Adapting to Change

The houses were added onto as the family grew, and block-like appendages stretched from the rear and side of the house. The most common addition was a narrow ell placed behind the buttery so it did not eliminate a kitchen window. This new space would often serve as a summer kitchen.

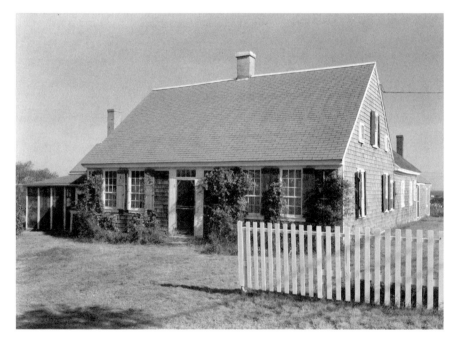

One of the oldest, largest and least altered houses in the Cape Cod National Seashore, Truro's Isaac Small House was owned by a family of prominent farmers. *Courtesy of Library of Congress.*

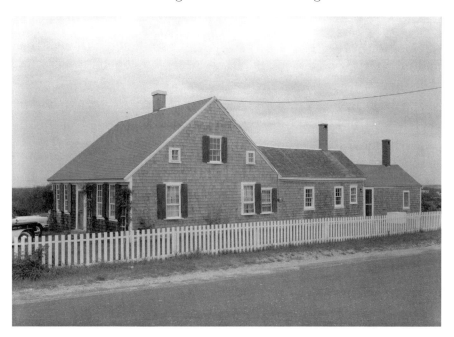

Originally constructed as a "double house," the house had ells added on over the years. View from the southeast. *Courtesy of Library of Congress.*

The view from the north offers another perspective of the home's increased footprint. *Courtesy of Library of Congress.*

As time went on, additions were made to the ell until they stretched all the way to, and often connected to, the barn. In addition to providing more living space, this move made it possible for family members to avoid going outside in the cold, wet weather. Even though additions have been made to most early Capes, the original structure usually stands out boldly.

To accommodate additional changes in the family and circumstance, early Capes were often moved to sites where there was more land for farming. Houses were simply placed on rollers and hauled across the countryside by horses. Houses were not only floated across numerous ponds and inlets throughout the Cape, but they also were floated across the ocean on barges, sometimes at great distances, such as from Nantucket, across Cape Cod Bay. It was said that houses could be transported with contents intact. Houses were mobile for a couple of reasons in addition to their modest stature: they were low slung, with minimal underpinnings, and were extremely sturdy.

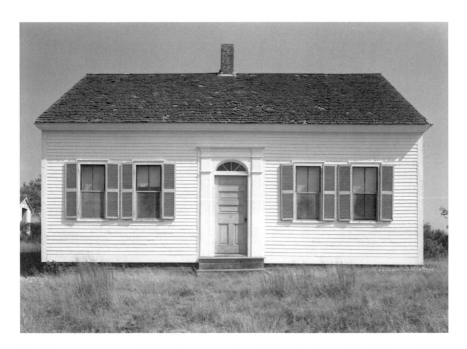

The Warren Rich House in Truro is an example of a Cape Cod–style "double house" with Greek Revival details, including high walls, fan light above the front door and a clapboard front. *Photo by Cervin Robinson.*

While traditional Capes were built through the nineteenth century, by 1850 they were no longer the singular style of the area. The advent of the stove in the 1840s altered the Cape's most evocative architectural elements—the massive chimney and hearth-focused layout—as advances in heating required smaller chimneystacks, and flues for stoves could be located anywhere in the plan. Families closed over existing fireplaces and rearranged closets and stairs. European styles, including Georgians, Federals, Greek Revivals and Victorians, were being built throughout the region and even influenced Cape Cod designs. Some Capes reflected pediments or moldings and fanlights flanking doors found in the Georgian and Federals of the era, and others were built with entrance porches reminiscent of those with Ionic or Doric columns on Greek Revivals.

REVIVING THE STYLE

The Cape Cod house saw a revival in the 1930s as architects throughout New England and the rest of the country took interest in the style due to the times—the Depression had created a desire for affordable, compact houses. Boston architect Royal Barry Wills brought national attention to the house through books, including *Houses for Homemakers*. Wills believed that Capes were a suitable prototype for the contemporary small home. After studying the historic Capes of the region, he refined the style for a middle-class family's needs. He retained the essential hallmarks of the low-to-the-ground seventeenth-century Cape, with its steeply pitched roof over a story-and-a-half structure, traditional central chimney and ells that implied the house had been expanded over generations. Modern Capes had formal living and dining rooms and large bedrooms, along with garages instead of the keeping rooms and parlors.

In his 1946 book *Planning Your Home Wisely!* Wills wrote, "I suppose the reason Cape Cod Houses are so popular is that they are the simplest expression of shelter. They lend themselves to a minimum of detail and a maximum of comfort." Other developers adopted the Cape and encouraged young families, many of whom were GIs returning from World War II, to buy the homes. Plans and models for Cape Cod–style

homes were distributed all over the country, and they were built in large measure in planned communities, including Levittown in Long Island, New York. Neat and nostalgic behind white picket fences, Capes were efficient, easily built with stock materials and economical, which enabled a great number of families to finally grasp the American Dream of owning their own home.

Born out of necessity, with a lack of self-consciousness, the houses the first Cape Codders constructed were no more or less than they needed to be. Overall, the Cape Cod house is an extremely simple structure. Yet its even proportions, functionality and affordability make the house ingenious, charming and immediately identifiable as a place of comfortable shelter. At the most basic level, it is this ubiquitous house that originated on the shores of Cape Cod that children drawing houses depict. There is usually a door at the center of a square or rectangular box flanked by a couple of windows with a straight, steep roof with a chimney rising out of it.

Built coast to coast, the once humble Cape is now one of the most popular American-style houses. It remains one of the most prevalent, if not the most common, home design on Cape Cod. While many historic Capes have been preserved with reverence to their origins, today's Capes are constantly modified. Windows have been enlarged for light and ventilation, and dormers have been added to make the second floor fully useable. Multiple windows in the gables have given way to one or two larger windows. Some houses stretch end to end roughly one hundred feet, decidedly different from the early Capes that grew—sometimes to the same length—toward the back lot line. Floor plans and footprints may be flexible, but the Cape Cod house is still unmistakably the Cape Cod house.

Chapter 2

THE WHALING ERA

GEORGIANS, GREEK REVIVALS AND SECOND EMPIRES

As Cape Cod approached the nineteenth century, there was great change in the area. No longer a humble and desolate enclave, the area's harbors were bustling ports. Local harbors regularly welcomed packet ships from Boston, and stagecoaches from the city bound for Provincetown stopped at area taverns. The shipbuilding business prospered, and men took to the high seas to seek their livelihood.

Seafarers earned their biggest profits from whaling. Cape Codders had been practicing drift whaling—harvesting a whale that washed up onshore—and inshore whaling—hunting whales close to shore in small boats with harpoons made with sticks, stones and bones—since the late seventeenth century. Whales provided the early colonists with food, bones for tools and other survival needs, and income from their sales could provide a modest living. By the 1800s, the demand for whale products had dramatically increased throughout America. Many parts of the toothed whale could be used to make products people desired. Blubber from sperm whales produced high-quality oil, as well as a waxy substance called spermaceti, which could be made into smokeless candles that produced a bright, clear, light, and ambergris, which was used in making perfumes.

According to the National Park Service website,

> *Whalers also profited from a material found in the mouths of toothless whales, known as baleen, a flexible material up to twelve feet long and six inches wide. Baleen grows in comb-like row and hangs from the whale's jawbone. Because of its versatility and strength, baleen was fabricated into a variety of functional and decorative objects, from baskets and fishing line to frames and petticoats. The raw material is comparable to present-day plastics and was commonly used by the brush industry for bristles.*

As the demand for whale products increased, more and more men became involved in whaling. When Thoreau visited Truro in 1855, he noted that five hundred men and boys "were abroad on their fishing grounds"—nearly one-third of the town's population of eighteen hundred at the time. As a result of the increased number of whalers, the waters of the Atlantic off the shores of Cape Cod became overharvested, and ships needed to go farther and farther away from their homeports to make a profit. Even boys as young as ten years old took to the sea as cooks or cabin boys, and by the time they reached twenty, they were masters or owners of their own ships. To successfully hunt whales, it became necessary to travel the world's oceans. Ships were redesigned to be wider, longer and sturdier to carry the necessary number of men, food and equipment for the voyages, which typically lasted from two to four years.

Thoreau was respectful of the lives of the whalers. Upon his excursion to Truro, he wrote:

> *A great proportion of the inhabitants of the Cape are always thus abroad about their teaming on some sort of ocean highway or other, and the history of one of their ordinary trips would cast the Argonautic expedition into the shade. I have just heard of a Cape Cod captain who was expected home in the beginning of the winter from the West Indies, but was long since given up for lost, till his relations at length have heard with joy, that, after getting within forty miles of Cape Cod light, he was driven back by nine successive gales to Key West, between Florida and*

Cuba, and was once again shaping his course for home. Thus he spent his winter. In ancient time the adventures of these two or three men and boys would have been made the basis of a myth, but such tales are crowded into a line of short-hand signs, like an algebraic formula in the shipping news.

Grueling and dangerous, whaling excursions were not for the faint of heart. Even the hardiest of men could become sick or injured. Some men died on nearly every trip; others jumped ship. It was also tremendously taxing on the families waiting for the seafarers at home. However, sea captains and their men who arrived safely home after a journey returned flush with the fruits of their labor. Not only would they come bearing cash dividends from the sale of their catch, but they would also have goods—furniture, china, artwork, jewelry for their wives, toys for their children—from their travels to exotic locales including China, India, the South Pacific and parts of Europe. As the maritime era boomed, ships and shipmasters attained great renown for their seafaring ability and financial acumen. As testaments to their wealth and social standing, captains built stately homes with detail and embellishment—a vast departure from the simple, compact Cape Cod–style structures of the previous era.

EARLY GEORGIAN DESIGN

Among several architectural styles to emerge on Cape Cod during the second half of the eighteenth century and throughout the 1800s was the Georgian. A sophisticated, often elegant British design, Georgians were classified by three different types: Early Georgian, Middle Georgian and Late Georgian. Houses were still built with massive timber frames, but now these beams were usually covered by wooden cases. The ceilings were plastered, and moldings and wood paneling graced the walls and doors to conceal joints and changes of levels and for decorative affect. The main characteristic of Georgian style was symmetry. The houses, which always had two full levels, had square or rectangular plans, and the façade, the public face of the house, was paramount. Windows

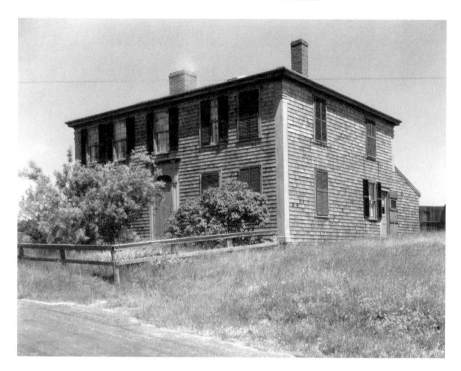

Built in 1809, Chatham's Christopher Ryder House had elements of Early and Middle Georgian design, including a hip roof, dual chimneys and double-hung sash windows. *Photo by Arthur C. Haskell.*

were symmetrically placed, usually in five bays. Like the Cape Cod house, overall window proportions were still fairly narrow, but they were now double-hung sash with larger panes of glass, and they were not typically framed with shutters. Unlike the simple six-paneled doors of the Cape Cod style, Georgian front doors were always treated with extra decorations. Filigreed fanlights that allowed plenty of light inside, canopies and pediments were prominent features of the doorways.

Many Early Georgian houses exhibited gable roofs (less steep in pitch than Capes because houses had full second stories), yet as the style evolved, the pitched roof was replaced by the hip roof. The hip-roofed house was often called a "square-rigger" or "captain's house." Also similar to Capes, the first Early Georgians had central chimneys that dictated the floor plan, but as time went on, the central chimney disappeared in favor of two or more chimneys either at gable ends or centered between

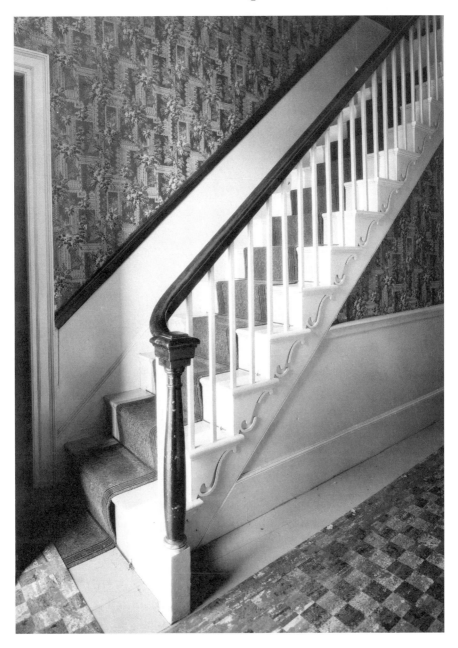

The stairway of the Christopher Ryder House was indicative of the Georgian era: part of the entrance hall, it was decorated with carved details. *Photo by Arthur C. Haskell.*

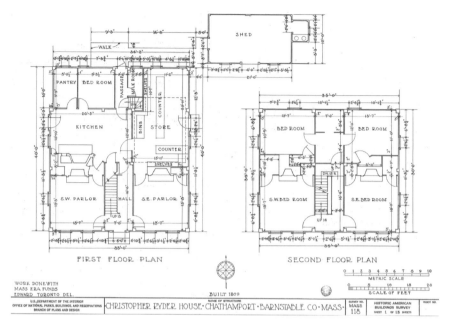

A floor plan sketch of the Christopher Ryder House. *Photo by Arthur C. Haskell.*

the front and back rooms. While stairways in Cape Cod houses tended to be tucked away, during the Georgian era stairways became part of the entrance hall. They were decorated with special care. As the century progressed, they became lighter and more elegant.

Though a lot of attention was given to the entrance door, interior doors were often paneled and left unadorned. Hardwoods were left plain and simple, while the softwoods were painted or grained in dark colors. A typical room was wainscoted. Earlier moldings were carved in wood so they were very heavy, but as the plaster was introduced, cornices and moldings became lighter. The new house styles introduced Cape Cod residents to new, more comfortable concepts of living. No longer confined to just a few spaces, new rooms allowed for separate living spaces for sleeping, cooking, dining and entertaining.

WINSLOW CROCKER HOUSE

Built in 1780, the Winslow Crocker House in Yarmouthport is a shining example of Early Georgian design. The classically well-proportioned house features twelve-over-twelve small pane windows and a second-floor layout that exactly mirrors the main floor, with two bedrooms over two front parlors. A common room with a hinged wall that can be raised or lowered to provide one large meeting space or two smaller rooms is located above the rear keeping room, which features the classic large cooking fireplace. The house, built in West Barnstable by Winslow Crocker, a well-to-do land speculator and ship builder, was moved in 1936 to its present location. While the original bricks were lost when the house was moved, it was otherwise reconstructed as it had been, with some improvements, including the addition of running water and heat. The house has six fireplaces around a central chimney, and the masonry is unique, with the bricks spiraled in a technique called "corbelling" believed to be used to protect the house against strong winds.

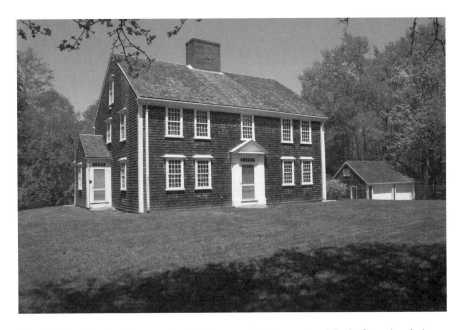

The Winslow Crocker House, a classically symmetrical example of Early Georgian design.
Photo by the author.

The house features thirty-six interior doors, which is a lot for the time period, an element that may have something to do with the fact that Crocker was a shipbuilder or that he was wealthy and could afford such novelties. While the walls have been plastered, in Crocker's time the walls would have been painted in pale pastel colors or papered with imported wallpaper. There is evidence that the house was split down the middle at one time to accommodate two families, which likely occurred when Crocker died and he left the home to his two eldest sons, rather that just the eldest, which was an English tradition.

The house was moved in 1936 by Mary Thatcher, an avid antiques enthusiast, to showcase her vast collection of seventeenth-, eighteenth- and nineteenth-century furniture. She donated the house to Historic New England, which currently operates the home as a museum to the public. Today, the house is packed with an impeccable array of antiques that range from the Jacobean to the Chippendale eras. Among the collection is a Brewster chair and children's cradle dating back to the 1600s, a Queen Anne woman's secretary from the late 1700s and highboys, beds and tables representing a range of early American styles.

Middle and Late Georgian Design

Middle and Late Georgians propelled the style into greater sophistication. As with the Early Georgian, its predecessors were invariably two rooms deep, a double-pile plan that consisted of two rooms situated one behind the other on each side of a central hallway. Style was everything. The pitch of the roof was lower and continued to evolve to a lower and lower profile. Houses were two and three stories tall, with the second story not as tall as the first and the third, which usually had dormers in the roof, not as tall as the second. (The sense of height was also diminished by placing the houses upon a basement, whereas earlier houses had sat right on the ground.) Many sea captains built Georgians with cupolas, while others exhibited widow's walks, railed rooftop platforms where wives would go to scan the horizon for the return of their husbands' ships.

Doorways became more elaborate, exhibiting more refined segmental and triangular pediments along with fluted pilasters flanking the doorways. Entranceways also exhibited central pavilions, porticos and double porches (one above the other). Rather than having weathered wood exteriors, houses were painted light colors. Houses tended to have five, sometimes seven, symmetrical bays, and windows had larger panes and were framed by shutters. There was also increased architectural treatment on the interior. Fireplace surrounds were detailed, as were balustrades and railings. Pilasters were painted bright colors, and imported wallpaper and stucco joined surprisingly bright color schemes.

A Middle Georgian example is the Julia Wood House. Built in Falmouth in 1794, the house features a hip roof and two chimneys, an architectural element that, by obviating one central chimney, made it possible to have expansive central hallways on both the first and second floors. The house, built by Dr. Francis Wicks, the man responsible for opening the Cape's first hospital in Falmouth by Nobska Lighthouse,

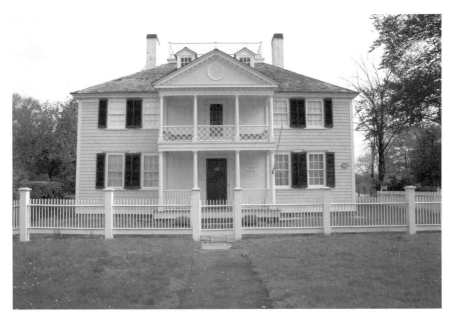

When it was built at the turn of the nineteenth century, the Julia Wood House was considered the finest house in town. *Photo by the author.*

The Captain William Bodfish House, a Middle Georgian built in 1814. *Courtesy of the Falmouth Historical Society.*

features a two-story open porch with a pediment roof and modillion cornice along with a widow's walk. After Wicks passed away, the house, considered the most gracious in town, was purchased by Captain Warren Nye Bourne, a master of several whaling ships, who lived there for nearly forty years. Now a museum operated by the Falmouth Historical Society, the house has both a main kitchen and a summer kitchen, each equipped with fireplaces and stoves, added at a later date.

Next door to the Wood House, the equally impressive Captain William Bodfish House features hallmarks of Middle Georgian design with a hip roof, enclosed widow's walk and twin chimneys. The house was built in 1814 for whaling Captain Bodfish, who was said to be the youngest man to attain full rank as master of a large vessel known on the Cape, and his wife. At the time it was constructed, the house was the latest in elegance, an example of the wealth brought to the town with the whaling trade.

GREEK REVIVAL STYLE

The Greek Revival house brought about a profound change to the architecture of Cape Cod. Appearing in the area about 1820, Greek Revival houses incorporated features of ancient Greek temples: symmetrical shapes, low rooflines, columns, pediments and pilasters. At the time, the style was thought by Americans to embody the concept of democracy, and it was the most popular style among sea captains. The traditional Cape Cod–style house even featured the Greek Revival influence with the development of higher cornice lines, deeper friezes—horizontal bands that run above doorways and windows or below the cornice—and wider corner boards.

On Cape Cod, the houses tended to be constructed of white clapboard with dark green or black shutters. While the Cape Cod house featured gabled ends on each side, the gabled end of a Greek Revival house was turned to the front. In larger examples, the front door was set in the center, while the entrance was often to one side of the gable in smaller, three-bay versions. In each case, the door was flanked by a varying number of windows, which were typically six-over-six panes. Ground-floor windows were often taller—on the most elegant Greek Revivals they were nearly floor to ceiling in height—than second-story windows. Corner boards were replaced by pilasters, there were heavier door and window surrounds and entryways were elaborate, with engaged columns, sidelights and transoms.

Almost all Greek Revival houses featured front or side porticos or porches supported by columns or pillars. Chimneys were narrow and placed toward the back of the house. Usually one and a half to two main stories tall, houses featured a front entrance hall with a staircase and parlor. Behind these rooms, single file, were small bedrooms. Ells were set at right angles to the main house instead of to the rear, and the large room in the ell was much like the keeping room of older houses. Later, when summer kitchens were added, the room became a dining room. The second level featured more bedrooms. One usually had to pass through the front rooms to get to those in the back, so second staircases located at the back of the house were often part of the floor plan.

B.S. Young House, a Wellfleet Greek Revival built about 1840. *Photo by Cervin Robinson.*

Due to early settlement and intensive land use, by the 1830s, vegetation was severely diminished and trees were scarce. As all heating was by wood, and it took ten to twenty cords of wood to heat a home, coupled with the wood that was needed for building, most of the Cape's native oak forest was cleared early on, and lumber was being shipped as deck cargo on schooners from Maine. With the Greek Revival, the Cape's construction methods dramatically changed. Studs, joists and rafters were used for the first time. On his visit to the region about 1850, Thoreau remarked: "The modern houses are built of what is called dimension timber imported from Maine, all ready to be set up, so that commonly they do not touch it with an axe." Indeed, the trees had been felled and cut into sized lumber before shipping.

Captain Bangs Hallet House

The Captain Bangs Hallet House in Yarmouthport is a classic Greek Revival. While parts of the structure were constructed in 1740—the

kitchen still contains the original 1740 brick beehive oven and butter churn—the gracious house was virtually entirely rebuilt one hundred years later by Thomas Thatcher, a prominent store owner who gave the house the most stylish decorative treatment and furnishings of the era. His tenure at the home was short-lived, and a few years later, the house was sold for $2,600 to sea captain Allen Knowles. The Knowles family would also inhabit the house for a short time; in 1860, Knowles traded houses with another Yarmouth sea captain, Bangs Hallet. Hallet, a captain in the China–India trade for more than thirty years, had just built an imposing new home down the road. However, his latest voyages hadn't reaped the rewards he had hoped, and the expense of building the new house had put him in a financially precarious position. Knowles's journeys had fared better, and he wanted a larger home, so the two swapped residences.

Captain Hallet and his wife, Anna, who were married for almost sixty years, inhabited the house from 1863 to 1893, and while it was a less assuming house than their previous home, the three-level structure with a Doric-columned front porch had large, airy rooms and a dignified air that indicated that Captain Hallet was a man of some substance. Sea captains filled their houses with fine furniture collected on their voyages. They imported wall coverings and draperies from overseas. While their fortunes were less, the Hallets had a proud collection of exported goods.

Presently, the house, operated as a museum by the Historical Society of Old Yarmouth, is furnished in the nineteenth-century style of a typical sea captain's home, including many artifacts that belonged to the Hallets. In the master bedroom, at the foot of the canopied maple bed, sits the leather-bound chest Anna brought with her when she traveled with her husband—an occurrence that was rare, as her health was frail and she proved to be a poor sailor. A curly maple slant-lid desk, Chinese lacquer sewing stand and large Chippendale wingback chair complete the room's furnishings, and Anna's clothes are in bureau drawers, her prayer book on the table beside her bed. In the parlor downstairs are portraits of Captain Hallet and Anna in Chinese Chippendale frames, a Hepplewhite sofa, a set of Hitchock chairs and a Sheraton secretary. The collection of artifacts throughout the rest of the house includes navigation instruments, pewter, Chinese Canton Ware, scrimshaw, pewter and ship's models.

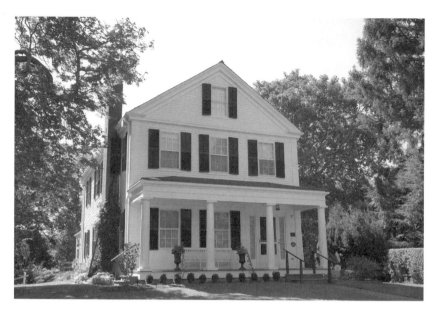

While the majority of the Captain Bangs Hallet House was built in 1840, parts of it date back to 1740. *Courtesy of the Historical Society of Old Yarmouth.*

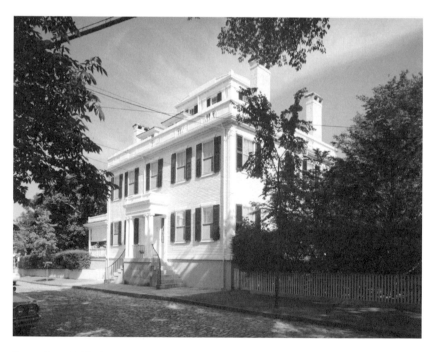

Front view of John Wendall Barrett House, an elaborate Greek Revival. *Photo by Cortlandt V.D. Hubbard.*

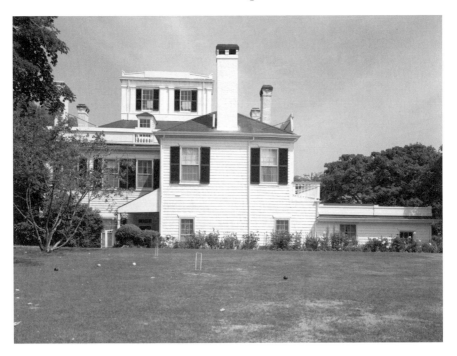

Exterior façade of John Wendall Barrett House. *Photo by Cortlandt V.D. Hubbard.*

Built in 1820, the John Wendall Barrett House on Nantucket is an example of a more elaborate Greek Revival style. The façade's dominant feature is a front portico with Ionic columns, and a large cupola on the roof has Greek Revival decorative details. There is another porch to the left side of the house. The house has a high brick basement, and clapboards are used on all sides of the house—in less refined Greek Revivals, clapboards were used on just the front, while the back was covered in shingles, a cheaper material. The details of the house are so finely executed that the transition from masonry work to a working of the same details in wood has been achieved.

SECOND EMPIRE

As the success of the whaling industries and export trades increased, the structures built on Cape Cod during the Victorian age from the 1830s

into the 1900s showed an increasing number of ornate architectural details. While architecture up to that point had been dictated by the huge chimney or chimneys needed for heat, the invention of the stove reduced the importance of the chimney, and builders could abandon the square house and add projections of wings and gables, turrets and verandas and bay windows.

The impressive Second Empire style was inspired by Napoleon III, who was remembered for the rebuilding of Paris into an impressive modern capital with grand boulevards lined by monuments and town houses with mansard roofs. In America, a variety of projects were built throughout America in the Second Empire style, including commercial structures, hotels and residences. Considered contemporary and inspirational, the style was especially popular during Ulysses S. Grant's term in office and was thus associated with his prosperous administration; it was sometimes referred to as General Grant style.

The Second Empire's hallmark was a mansard roof, in which the upper part typically intersected with a flat roof that extended over the middle of the building. An advantage of the roof was that it allowed for commodious upper-attic storage space because the slope from eaves to ridge was broken into two portions. The lower portion was built with a steep pitch, sometimes almost vertical, while the upper one is pitched low or is nearly flat. The elegant Second Empire homes built by prosperous Cape Codders began to appear in the area about 1850 and were most common throughout the lower Cape and particularly in Provincetown.

In addition to tall floors and heavy moldings, almost all Second Empire structures featured towers or cupolas on the roofs, and houses were formal, rectangular and symmetrical. Integral to the design were one-story porches, supported by paired or ganged columns and elaborate brackets, across the front façade of the house; porches were also added frequently to the sides and backs. Windows were large, with two-over-two pane double-hung sash with rounded or segmental arched tops. First-floor windows often reached floor level, while windows on upper floors were dormered and heavily decorated. While the Greek Revivals of the preceding period had been painted an unassuming, if not monotonous, white, Cape Codders were anxious to enrich their architecture with some

color, and exteriors of Second Empire homes were painted multicolored rich earth tones to pick out their ornate details. Roofing materials also showcased decorative patterns of color and textures; roofs were often covered with slates in fish-scale patterns, and cast-iron cresting lined the top of the mansards.

Captain Edward Penniman House

The most stunning expression of Second Empire style on Cape Cod is the Captain Edward Penniman House in Eastham. Penniman began his life at sea at age eleven and was whaling in international waters by the time he was twenty-one in 1852; at twenty-nine, the native Eastham resident was the captain of his own ship, which was docked in New Bedford Harbor. While his letters home indicate that he did not like his life at sea, he could not pass up the wealth he acquired from his voyages. In a letter to his young son Neddie, Penniman wrote: "I hope you will not be a sailor. At best it is a miserable life to follow, full of hardships and trials, to say nothing about being away from home, and friends for long years at a time."

To make his long years at sea more bearable, Penniman took his family on several voyages. Unlike Anna Hallet, Captain Penniman's wife, Gustie, appeared to enjoy life on the ocean. An excellent navigator, Captain Penniman entered ports in the Arctic, Cape Verde Islands, Hawaii and New Zealand. Overseas, the Pennimans were very cosmopolitan. Sometimes the family stayed long enough for the children to attend school and dress in local costume and for Gustie and Captain Penniman to socialize with foreign heads of state.

Captain Penniman went on to become one of the most successful whalers on Cape Cod, and when he retired at age fifty-three in 1884, he was one of the most prosperous captains in New England history. According to the National Park Service, "In 1860, whale oil sold for $1.45 per gallon, sperm oil sold for $2.55 per gallon and whalebone sold for $15.80 per pound." Records indicate that over the course of seven international voyages, Captain Penniman's ships carried thousands

of barrels of whale oil and more than 100,000 pounds of whalebone. After acquiring twelve acres of land in the Fort Hill Section of Eastham from his father in 1868, Penniman decided to build a grand home with the massive proceeds he had acquired on his excursions. The worldly Pennimans had no qualms about building a modern mansion featuring the most up-to-date trends to showcase their treasures. Few homes on Cape Cod could so accurately depict the true extravagance and affluence of whaling's heyday as their home did.

The Pennimans spared no expense building the most extravagant house in Eastham—perhaps on the whole Cape—at the time. Designed by an established architect whose identity is unknown, the two-and-a-half-story Second Empire house, located on a cliff overlooking the Atlantic Ocean, was set on a stone foundation and was painted in a colorful scheme of yellow clapboards, white trim, black window sashes, green window blinds and brown and red roof shingles. According to the National Park Service, "Captain Penniman kept detailed records for the

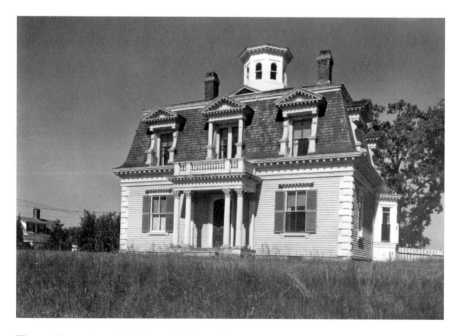

The southwest view of the Captain Edward Penniman House shows the structure's large two-over-two pane double-hung sash windows with arched tops. *Photo by Cervin Robinson.*

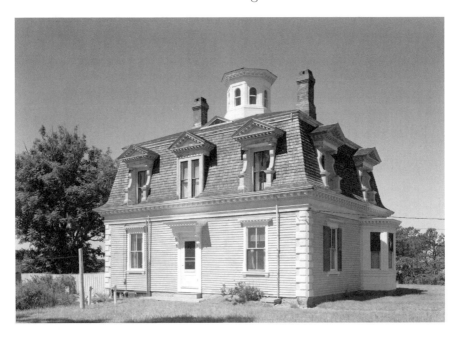

View of the house from the northeast. *Photo by Cervin Robinson.*

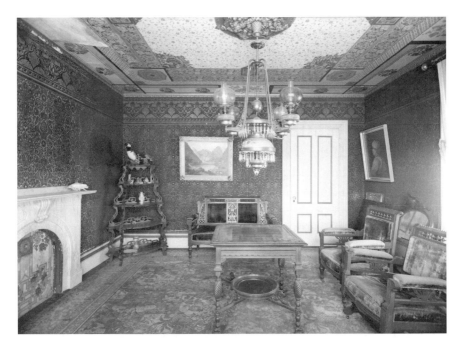

The parlor featured fine furnishings, finishes and fixtures, including a marble fireplace, a rug from the Orient and hand-blocked wallpaper. *Photo by Cervin Robinson.*

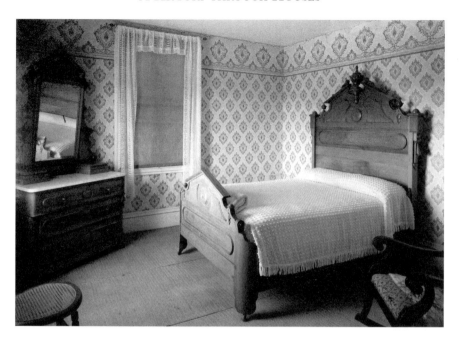

A second-floor bedroom contains original furniture and wall coverings to this day. *Photo by Cervin Robinson.*

expenses related to building the house: he paid $15.00 for digging the cellar; $24.99 for 238 pounds of nails; $17.88 for 511 feet of hard pine lumber; and $21.60 for eight days of exterior painting."

The symmetrical interior contained two rooms on each side of a central hall. Hardware, wall and ceiling coverings were lavish, and woodwork had a grained finish. Furnishings from around the world included European paintings, scrimshaw and Arctic bear robes. The house featured state-of-the-art home technology and was the first in the area to have running hot water. An innovative rainwater collection system was located on the roof. Water was collected and directed to a cistern, a large tank in the attic, and was piped through a gravity flow water system to the kitchen and bathroom from there. Additionally, the house had an oil-fired hot-air furnace and electric lights.

A barn on the property reflects the overall style of the house, replete with a tower on the mansard roof and an openwork fence resembling a ship's rail curved around the yard. After the house was built, thirteen-

The secretary desk where Captain Penniman recorded notes of his journeys and kept correspondence. *Photo by Cervin Robinson.*

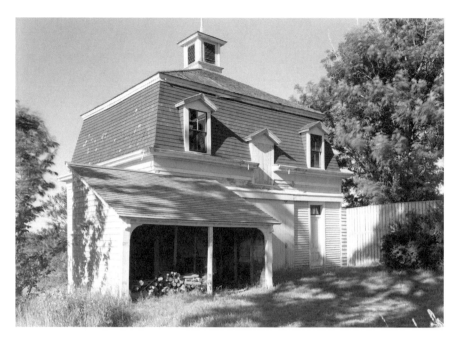

The barn was built in the same Second Empire style of the Penniman mansion. *Photo by Cervin Robinson.*

foot-tall whale jawbones were placed as an arched entrance gate to the property; at the time, it was thought to be good luck to pass between whalebones.

Miraculously, the house exists today almost entirely as it did during the time Captain Penniman lived in it—he resided there until he passed away in 1913. Located within the boundaries of the National Seashore, the house is operated as a museum by the National Park Service. The exterior remains in its original appearance, and the interior woodwork, finishes, hardware and wall and ceiling coverings have been preserved. The contents of the house include Captain Penniman's written records (letters, diaries and journals), navigational tools from his ships, many original furnishings and over one hundred glass-plate negatives on display that capture the house, the Penniman family and the serene Cape Cod landscape of the nineteenth century.

Chapter 3
CAMP REVIVALS AND CARPENTER GOTHIC ARCHITECTURE

By the early 1800s, outdoor religious revival gatherings were popular throughout the country. Known as camp meetings, revivals were born on the western frontier, and revivalism took many forms. In the East, people from a wide range of religious denominations and ethnic and societal backgrounds attended six-day-long camp meetings during the summer. Led by skilled preachers, revivals were both disciplined and festive affairs with preaching and singing day and night. The atmosphere prompted many nonbelievers to convert to Christ's cause. News that a religious meeting was scheduled was spread by word of mouth, newspaper advertisements and posters. Lured by the idea of a spiritual renewal, families also considered the meetings to be a vacation, a much-needed respite from their day-to-day work where they could meet up with old friends and make new acquaintances. They often traveled for several days to reach the meeting, and once they arrived, they set up tents and camped out.

CAMP MEETINGS COME TO THE CAPE

Methodist preachers found the tranquil, unspoiled landscape of Cape Cod to be an ideal spot to hold camp revivals, and the first meeting took

place during the summer of 1819 in South Wellfleet. The tent revivals were a mixture of religion and entertainment, and many of those who attended the meetings were not even Methodists. Camp meetings also took place in Provincetown and South Truro. In 1828, the Cape's summer revivals moved to Eastham's Millenium Grove, a ten-acre oak grove beside the ocean that provided a serene natural atmosphere for spiritual renewal.

The low cost of camping out in tents made the excursion affordable for many people. Thousands of people attended for a week every August, listening to numerous preachers for hours on end. When Thoreau visited Eastham in 1855, he commented on the campground:

> There are sometimes one hundred and fifty ministers (!) and five thousand hearers, assembled. The ground, which is called Millenium Grove, is owned by a company in Boston, and is the most suitable for this purpose than any that I saw on the Cape. It is fenced, and the frames of the tents are, at all times, to be seen interspersed among the oaks. They have an oven and a pump, and keep all their kitchen utensils and tent coverings and furniture in a permanent building on the spot. They select a time for their meetings when the moon is full. A man is appointed to clear out the pump a week beforehand, while the ministers are clearing their thoughts; but probably, the latter do not always deliver as pure a stream as the former. I saw the heaps of clam-shells left under the tables, where they had feasted in previous summers, and supposed, of course, that that was the work of the unconverted, or the backsliders and scoffers. It looked as if a camp-meeting must be a singular combination of a prayer meeting and a pic-nic.

Thoreau also remarked that "the attention of those who frequent the camp-meetings at Eastham, is said to be divided between the billows on the back side of the Cape, for they all stream over here in the course of their stay. I trust that in this case the loudest voice carries it. With what effect may we suppose the ocean say, 'My hearers!' to the multitude of the bank!"

Tent Layout

Campgrounds were divided into family tents and society tents. Tents were made out of canvas and muslin, and if stored away between seasons and cared for properly, tents could last a long time. Society tents were used to provide meals, refreshments, groceries, newspapers and books, haircuts and more. Some of the tents were quite large with painted floors, walls and frames. A typical family tent included a wooden floor, a wooden frame to support canvas covers and wooden ends to the frame. Each end included planking, screened doors and windows. In front of the tent was a wooden platform to serve as a porch. Every summer, families would stretch an inner canvas cover over the roof to the frame and down the sides and tie it to the wooden floor. An inner canvas was also applied to make a double roof. In addition to bringing the canvases from home each year, families had to bring along furnishings, including mattresses for permanently built-in wooden double beds with slats, daybed sofas, cots, tables and chairs. Outside, to the rear of the tent, a kitchen and eating area was established by raising a single canvas tent top supported by poles; the sides of the area were enclosed by wooden lattices. Cooking was done by a kerosene stove.

Yarmouth Campground

Attendees would arrive at Cape Cod camp revivals by horse and wagon, on horseback, by boat and even on foot. To attract off-Cape tourists, camp meetings were moved up the Cape to Yarmouth in 1863 to be near the new railroad. The Yarmouth Campground originally had about 175 family tents and 40 society tents. A circular wooden tabernacle seating 1,500 was eventually built. For seven to ten days every August, meetings took place in Yarmouth through 1939, and during the camp's peak in the 1860s and 1870s, the largest crowds on the grounds in a single day consisted of between 3,000 and 7,000 people. Not everyone would be at any particular service, but the principle afternoon service would often draw 1,500 to 3,000 people. Although most camp meetings

forbade smoking, drinking intoxicating beverages and such sinful pursuits as playing cards, there was a buzz to the revivals and the atmosphere was lively and joyous, as if the event were a fair or festival. Novelist Joseph Lincoln recalled attending a Yarmouth Campground meeting in his boyhood: "The ground moved up and down, stopping occasionally to listen to the preaching, or to join in the singing of Moody and Sankey hymns, or to sample the sandwiches and oyster stews or the candy or watermelons or tonic."

As the nineteenth century progressed, camp meetings offered a desired religious alternative to the secular, middle-class vacation resort. Campgrounds were also established in Craigville and on Martha's Vineyard in Oak Bluffs. At the Christian Camp Meeting Association's site in Craigville, there were two hotels, a large tabernacle tent, multiple family tents and smaller tents for sleeping, eating and barbering. As camp-goers discovered that their spiritual awakenings could be combined with leisure time at the beach, the Christian Camp Meeting Association bought 880 feet of prime beachfront property, what is now Craigville Beach. Encompassing twenty-six acres, the Martha's Vineyard Camp Meeting Association had a larger campground, known as Wesleyan Grove, so it was able to accommodate even greater crowds than Yarmouth and Craigville had the capacity to handle. At the campground's revival in 1853, there were fifty-three clergy and five to six thousand people in attendance, and five years later nearly ten thousand people participated in the annual meeting. In 1879, an iron-trussed tabernacle was built that had seating for four thousand people.

Carpenter Gothic Cottages

By the late 1860s, camp-goers had begun to replace family tents with Carpenter Gothic wooden cottages. Heavily influenced by Victorian architecture and a variant of the Gothic Revival style, Carpenter Gothic design emphasized verticality and was characterized by scrolled ornaments, lacy "gingerbread" trim and unique jigsaw decorations. Gothic cottages, small and of simple, affordable construction, were

a logical successor to earlier tents. They were harmonious with the purposes of camp meetings and seemed religious in nature, with a highly chapel-like appearance, appearing like tiny churches. With front porches running the width of the house, the main entrance was usually a double door opening inward, and often a little balcony off the main upstairs bedroom jutted over the front porch where another pair of double doors would allow furniture to be lifted to the upper rooms, as stairways were twisting and narrow. The outer walls were vertical boards that served as both siding and interior walls.

At the Yarmouth Campground, a cottage could be ordered in May and would be ready for the annual camp meeting three months later. While camp-goers found the prospect of not having to transport their furniture and household goods to the meetings every year appealing, they were also happy to discover that it was significantly cheaper to build a new cottage then it was to purchase a new canvas tent, which could cost upward of $350. In the 1860s and 1870s, the cost to build a cottage ranged from $150 to $250. By 1900, building a cottage was a still relatively modest $250 to $500.

The ten- by seventeen-foot frame of a basic cottage was of post-and-beam construction, with corner brackets resting on cedar posts. Whole walls were created from green lumber, mostly hard pine shipped from the Carolinas or Maine, in dovetail fashion. Two posts without studs were set eight feet apart, and as the wood seasoned, the joints became permanently welded together. Cedar shingles covered the roof. The windows and doors for the front rooms downstairs and upstairs featured pointed or round arches, while the remaining windows and doors were square. Cottages typically featured one or two bedrooms or wide-open sleeping lofts upstairs, while the first level consisted of the living areas. Arches, corbels, windowsills, balusters and brackets trimmed the windows, porches and doors, all of which were newly being mass produced after the Industrial Revolution and were available from lumberyards. Gingerbread was also a stock item, but most owners preferred to design and cut their own to express the individuality of their cottage.

Early campground cottages were typically painted white, and as time went on they began to feature earth tones that receded with the landscape, subtle

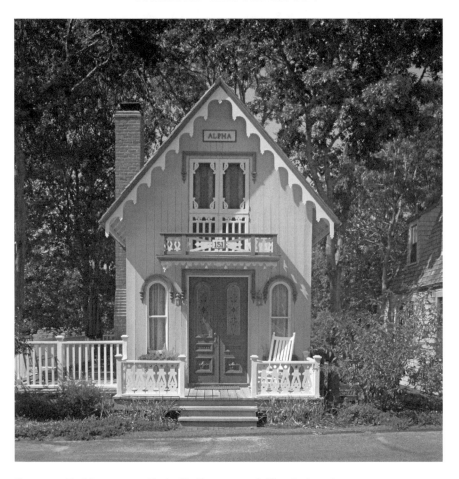

Carpenter Gothic cottage at Craigville Campground. *Photo by the author.*

shades resembling leaves, tree bark and stones. By the turn of the twentieth century, however, colors were brighter, bolder and more whimsical as owners discovered the vibrant shades were not only forms of self-expression but that they also accentuated the unique antique architectural details of the houses. As had been the case with the tents, light in the evenings was provided by kerosene lamps and lanterns. Cooking was done on kerosene or wood stoves, which also provided heat on cool days. It was well into the 1900s before water and plumbing were added to the cottages.

Although the walls were durable, the cottages were never really intended to be permanent homes. Yet many have stood the test of time,

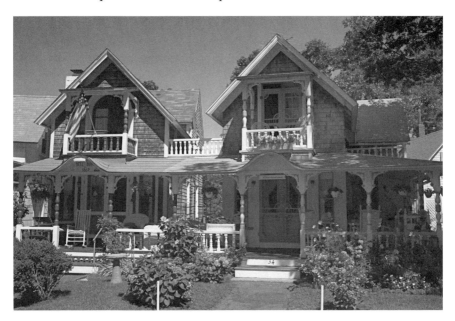

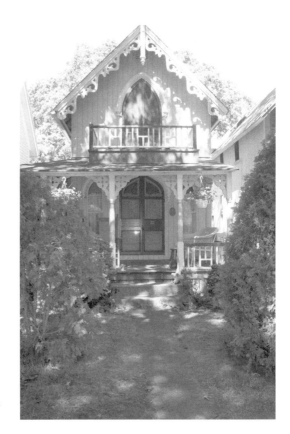

This page: Carpenter Gothic cottages at Wesleyan Grove, Oak Bluffs. *Photos by the author.*

lasting more than a century. The Craigville Campground still exists as a Methodist meeting camp preserve and conference center; many original cottages remain and are privately owned and used as summer homes. While the Yarmouth Campground no longer exists as a spiritual haven, it does have a delightful trove of privately owned nineteenth-century cottages. While most have been insulated and rebuilt to accommodate elements necessary for contemporary living, owners have taken care to retain the tiny cottages' rustic, original character and detail. Wesleyan Grove is still owned by the Martha's Vineyard Camp Meeting Association, and the area, encompassing more than three hundred of the original five hundred cottages, along with the historic tabernacle, is now a National Historic District. A museum in the Grove is devoted to showcasing the campground's interesting history to the public. Cottages are owned privately, yet owners only pay property taxes on their dwellings, since the land is owned by the association. The community consists of a small number of year-round residents and mostly summer residents, many of whom have had the cottages in their families since the 1800s.

GOTHIC REVIVAL THROUGHOUT THE CAPE

It wasn't just campgrounds that favored the Gothic style. Throughout the latter part of the nineteenth century, Gothic Revival houses were built throughout the Cape. Slightly less fanciful and more architecturally mature than Carpenter Gothic cottages, Gothic Revival houses drew inspiration from Medieval architecture and were closely associated with Romanticism. At the time, Gothic Revival was also a favored design of churches, and many were built in the style throughout the Cape. Andrew Jackson Downing, a Hudson River Valley architect, is largely responsible for the popularity of the Gothic Revival house. Downing, who believed that architecture and the fine arts could affect the morals of the owners and that improvement of the external appearance of a home would help "better" all those who had contact with the home, penned several instructional guidebooks on the style, offering advice and house plans for middle-class Americans. He detested the Greek Revival house style,

arguing that temples were not suited to American homes, and even demonstrated in his books how one might update a Greek or Georgian house and make it fashionably Gothic.

The Gothic house did not need to be symmetrical, as many prior house designs on Cape Cod had required, and it could be enlarged or expanded without fear of losing its picturesque qualities. The development of scroll saws made it possible for ornate decoration to be produced economically, so houses as well as some public buildings began to sport graceful ornamental gingerbread on bargeboards, porch columns and peaked gables and around windows.

Larger and of more sturdy construction than the small, seasonal campground cottages, Gothic Revival houses were constructed of vertical wooden board and batten siding and featured steep gabled roofs with complicated and picturesque lines with one or several interesting gables. Unlike all Cape Cod house designs prior, Gothic houses seldom featured rectangular shapes. Board and batten siding accentuated the elongated height of the houses as well as the tall pointed or arched windows with diamond-shaped panes that frequently included dormers. Dormers themselves were usually capped with steep gabled roofs and were heavily decorated with gingerbread, as was the rest of the house. Usually one and a half to two stories tall, unlike the camp meeting cottages, which had porches that typically ran along the entire front façade, larger Gothic houses tended to have several smaller porches. Chimneys were seen as important decorative accents and were ganged together in pairs or placed off-center. While most houses of the style had a storybook quality to them, they did not tend to be as whimsical as the campground cottages. Though, as with the cottages, color was an essential element, each home featured two colors: an exterior painted tan, brown, gray or perhaps red or dark brown, with the details painted several shades darker or lighter.

Lifesaving Stations and Keeper's Houses

Lighthouse keepers' houses and lifesaving stations were built along the shores of Cape Cod during the 1860s and 1870s. As a result, many of

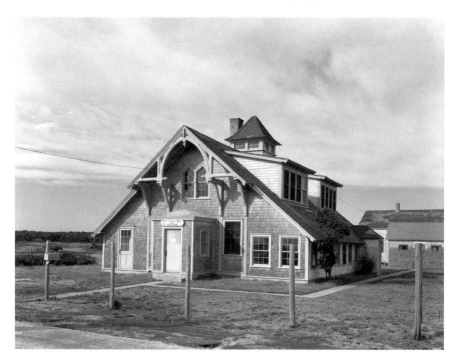

The first U.S. Lifesaving Station on Nantucket exhibited elements of Gothic Revival architecture. *Photo by Cortlandt V.D. Hubbard.*

the stations—built to house relief workers who rescued seamen from shipwrecked or stranded vessels—and most keepers' homes featured hallmarks of Gothic design. On Nantucket, the first U.S. Lifesaving Station on the island was built in 1874 at a cost of about $10,000. A rare example of the Gothic style, the building is clad with shingles rather than board and batten siding. Elaborate exposed trusses at either end of the structure, pointed second-story windows and a cupola are indicative of the embellishments associated with the style.

Located next to lighthouses, as the moniker implies, keepers' homes housed the lighthouse keeper and family, if he had one, as well as the occasional overnight guest—Henry David Thoreau spent the night at Truro's Highland Light on more than one occasion, an experience he quite enjoyed. Built by the government, keepers' houses were intended to be functional, spare quarters, yet this didn't prevent them from exhibiting understated Gothic details. The keeper's house at Nobska Lighthouse in

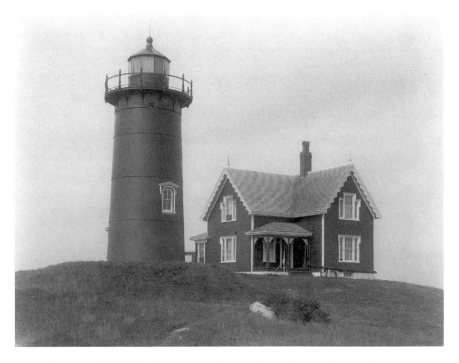

The tall, narrow Nobska Lighthouse keeper's house featured decorative scrollwork when it was built in 1876. *Photo by Baldwin Coolidge, courtesy of Woods Hole Historical Collection and Museum.*

Falmouth, built in 1876, is an elongated structure with steeply pitched gables featuring decorative scrollwork around the edges. While windows are not arched, as are found on more elaborate examples of Gothic architecture, they are tall and narrow and outlined by molding. Small porches are found on three sides of the house, which is painted a dark color; the details of the structure are accented in white.

FALMOUTH HEIGHTS

While camp meetings brought the first summer visitors to the Cape, by the early 1870s, other groups of middle-class individuals, lured by the attractive seashore, began to chart out the territory as a seasonal destination. The first planned resort community on Cape Cod was in

Falmouth, in a section known as Great Hill, the highest point of land along Vineyard Sound, which had spectacular vistas of the ocean and bluffs. In 1870, the resort site had just been cleared of the town's last saltworks, which had become unprofitable when a group of Worcester investors discovered and purchased the land that encompassed more than one hundred acres.

The developers incorporated themselves as the Falmouth Heights Land and Wharf Co. and immediately set about establishing the infrastructure for a middle-class resort community complete with cottages, hotels and stores, known as Falmouth Heights. The land was divided into six hundred tiny house lots, and several large areas of land were set aside for open space and park usage. Parks followed the natural contours of the land and included the picturesque Central Park, which provided a link between the hills to the west and flat lands to the east. Observatory Hill, the highest point in Falmouth Heights, was also a focal point. Targeting the largest possible market—the family of modern means, the average American—the developers' intent was to provide themselves with the maximum profit. The subdivision layout was centralized on the concept that cottages would have standard designs—the Carpenter Gothic style— and could be mass produced. Yet even though the cottages were cut from the same mold, they would exhibit individuality with imaginative detail and coloring schemes. Property deeds had extensive restrictions: dwellings were required to be set back at least ten feet from the road and five feet from adjoining lots; and the lots were to contain only one dwelling and necessary outbuildings. The original deeds also stated that "neither spirituous, intoxicating nor malt liquors shall be made, sold or kept for sale on the granted premises; that no game of chance shall be played for money or any other consideration; and that no mechanical trade or manufacturing shall be carried on on the granted premises."

A prominent Worcester architect, Elbridge Boyden, was chosen to design the layout of the community as well as spec cottages and a home for himself around Observatory Hill. Boyden designed cottages in Carpenter Gothic style that were small in stature but far more impressive and intricately detailed than those built on campgrounds. One of the most unique cottages was located at 3 Crown Avenue. The

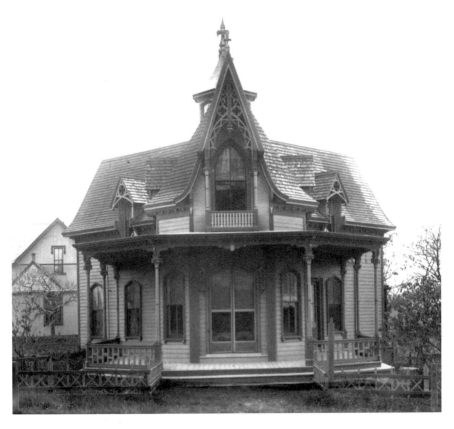

Whimsical, Y-shaped Carpenter Gothic cottage designed by Elbridge Boyden in Falmouth Heights. *Courtesy of Falmouth Historical Society.*

cottage is Y shaped, with the stem forming an open hallway, while the arms encompass the living quarters. With an ample front porch and an extremely steep roof, the house's gables and dormers are adorned with richly carved barge boards. The intersection of the three arms is crowned by a detailed cupola. Arched windows are narrow, long and framed with Gothic moldings. The house, constructed in 1872, was sold for $1,000 in 1880.

The other original cottages in Falmouth Heights were based on a T-shaped plan, with the cross forming the back of the house, while the stem formed the front's open living hall. The stem of the house was flanked by porches so that when one includes both the interior and

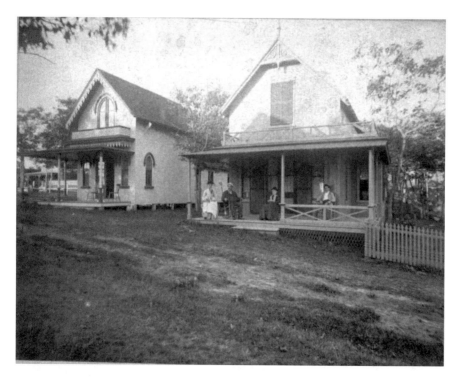

A couple of the fifty Carpenter Gothic cottages built in Falmouth Heights in the 1870s. *Courtesy of Falmouth Historical Society.*

exterior spaces embraced by the house, its plan was essentially square. The cottages were designed with an ample supply of windows, doors and porches to let in summer breezes.

By the end of 1871, more than one hundred lots had been sold in Falmouth Heights for about $200 apiece. Most of the buyers were from Worcester and its surrounding towns, with a few from Falmouth, and many of the purchasers were speculators who bought more than one lot, seeking to make profits of their own. Sales of lots continued through 1872, when the price was raised to $250, and developers sold nearly one hundred more. However, only about fifty Carpenter Gothic cottages were ever built—a fraction of the envisioned six hundred cottages. In 1873, the financial recession known as the Panic of '73 caused the Falmouth Heights Land and Wharf Company to fail. Yet the area slowly continued to grow through the ensuing depression. Plans to build a steamboat

wharf and an observatory, used as a gathering place where mail was distributed and news was discussed, were actualized. When the nation's economy recovered in 1890, interest in the development of Falmouth Heights soared, as did other planned communities across the Cape where vacationers could buy or build houses of their own and pursue a group-oriented social life based around evening dances and concerts at the hotel and daily boat trips, sunbathing and picnics.

Chapter 4
CAPE COD'S GOLDEN AGE

While Cape Cod had been a somewhat remote locale for its first two centuries, train travel made the region a much more accessible destination. Prior to the railroad, travel to the towns of Cape Cod was accomplished by packet boat, a journey from Boston to Barnstable that took seven hours. Riding by stagecoach was another method of travel, which took two full days, hardly the preferred mode of the busy traveler. The first leg of the Cape Cod Branch Railroad was established in 1848 with a line that extended from Boston to Sandwich to serve the burgeoning Boston & Sandwich Glass Company, a widely successful enterprise that produced fine hand-blown tumblers, whale oil lamps, cruets, glass hats, jugs and bottles. During its heyday, the Boston and Sandwich Glass Company employed more than five hundred workers—lured from all over the world—and produced over 100,000 pounds of glassware weekly. When Thoreau first visited the Cape in 1849, he took the train from Boston to Sandwich on the newly established line, and he found the ride a vast improvement over the stagecoach.

The railroad was extended to Yarmouth and Hyannis in 1854, and the line reached down to what is now known as Hyannisport, where passengers could board ferries bound for Martha's Vineyard and Nantucket. To extend the line to Orleans, in 1861 the Cape Cod Central Railroad was formed. In 1868, the Cape Cod Central and the Cape Cod Branch

Railroad were consolidated to form the Cape Cod Railroad Company. In 1870, the line reached Wellfleet, and by 1872, when the Cape Cod Railroad merged with Old Colony and Newport to become Old Colony Railroad, the tracks reached Woods Hole and Provincetown. Remarkably, the trip to the outermost point on Cape Cod was a miraculously short five-hour journey. The expanded rail line brought visitors from all over the country to Cape Cod, including President Ulysses S. Grant, who visited Provincetown during the summer of 1873. Provincetown archives record the occasion:

> *Train locomotive #25, the Extension, pulled into Provincetown from Boston. A second train, with a red funnel and Mount Hope painted on the sides, pulled 13 bright yellow coaches that included among its passengers three governors, one candidate for governor, Cape Cod political and business figures, and railroad officials. The great day came when flags flew, bells rang, and a great crowd came down to meet the train. At about 1PM on this date, the engine chugged around a curve and into the depot at Parallel and Center Streets, crowded almost to suffocation with townsmen who had ridden in from Wellfleet. Among the passengers was, reputedly, President Ulysses S. Grant. The first train was greeted by ringing bells and firing cannon; 800 guests dined beneath a huge tent erected near Town Hall.*

By 1887, fourteen of the fifteen towns on Cape Cod were connected by the railroad. Train travel significantly reduced the cost of transportation and the time required to reach the Cape. The completion of the region's railroad lines combined with the economic boom following the Civil War provided the middle and upper classes with the money and means to take vacations. In his travels from 1849 to 1857, Thoreau had noted that Cape Cod was "wholly unknown to the fashionable world." Yet he predicted, "The time must come when this coast will be a place of resort for those New Englanders who really wish to visit the seaside." By the 1870s, it was apparent that Thoreau had been right.

A Summer Destination Emerges

Novelist and travel writer for *Harper's Monthly* Charles Nordhoff, who visited Provincetown by train in 1875, envisioned the railroad's impact on tourism: "The railroad, as it is likely to change the old customs and break in on the simple life of the Cape, will also bring in new names and people." He noted that the region would please the "pleasure seeker who likes to get off beaten paths, and has an eye for a quaint country and a peculiarly American people." Bostonians discovered that Cape Cod offered an ideal respite form the city's oppressive summer heat: the Cape was often ten degrees cooler than Boston, and the constant ocean breezes and clean, fresh air were heavenly compared to the city's muggy and somewhat unsanitary conditions. Right along with the first trains that rolled into town, the first resorts appeared in Falmouth. Most of the Cape's early hotels were built along Buzzards Bay and to the west of Hyannis, in Osterville, Cotuit and Oyster Harbors. By 1888, there were more than one hundred hotels on the Mid- and Upper Cape and rooms for 3,500 guests.

In affluent families, mothers brought their children to the Cape, where they would take hotel rooms for a month or even the entire summer. Fathers stayed to work in the city during the weekdays and joined the family on weekends and for a week or two each season. The family ate all their meals at the hotel, and activities were centered there, too. Guests played croquet and tennis and enjoyed evening band concerts, strolls on the beach and sailing on catboats. Lots of time was spent simply sitting on porches, gazing at the sea and breathing the healthy salt air.

Among the Cape's elaborate resort hotels was Falmouth's Sippewisset Hotel, located on former farmland overlooking Buzzards Bay. Built by Boston music publisher John C. Haynes, the hotel was constructed in the Colonial Revival style. Expressing American patriotism and a return to classical architectural styles, Colonial Revival design sought to revive elements of Georgian architecture. The hotel cost nearly $67,000 to build and included a golf course, a pier, a horse stable, bathhouses, tennis courts, a casino for dances and games, bowling alleys and an electric generator. After the Hallet House in Hyannisport—a mansard-roofed

hotel that offered a bowling alley, billiards, a merry-go-round and a hall used for dances and theatricals—was built, the village emerged as one of the Cape's most popular upscale enclaves. The area attracted successful businessmen not only from Boston but also from cities spread all over the country, including Pittsburgh, Chicago and St. Louis. Indiana senator Thomas Taggart and Wisconsin governor Lucien Fairfield summered in Hyannisport, and steel and coal magnate and Ohio senator Mark Hanna managed William McKinley's presidential campaign from the village.

While Chatham first became popular with visitors in the 1860s when wealthy hunters arrived from Boston and New York to shoot waterfowl, it was the arrival of the railroad twenty years later that transformed the town into a major resort community. Several sophisticated hotels—some of which were of considerable architectural merit—were constructed in Chatham, situated at the point of the elbow, where Cape Cod bends northward to Provincetown. The most notable hotel was the elegant Chatham Bars Inn, which, unlike nearly all of the other great hotels of that era, is still in business. Designed by Boston architect Henry Bailey Alden, the Colonial Revival structure, unusual for its crescent shape, was crowned by steep pitched gambrel roofs with double rows of dormers, and the entire façade is fronted by a veranda supported by square brick piers. When it opened, the inn had amenities including electricity and running water, lacking in earlier Victorian hotels, and had twenty-four guest cottages of varying sizes on the premises.

Lavish Private Residences

While the grand hotels of Cape Cod offered a relaxing and social experience in seaside luxury, many wealthy individuals desired their own personal havens. As the economy continued to prosper, increasing numbers of affluent individuals took to building their own well-appointed summer residences. Houses represented a variety of styles, but most were of grand scale and design. The majority of these early lavish homes were concentrated in the area along Buzzards Bay from Woods Hole all the way north to Monument Beach. There were at

least a dozen summer colonies along this shore and hundreds of large, impressive summer residences.

The first noted summer residence in Falmouth was built in 1849, a bit before the resort era's heyday, for Albert Nye, a wealthy New Orleans merchant who returned to his hometown seasonally to escape the southern heat. Inspired by Louisiana's residential architecture and to help provide similar comforts for his southern bride, Nye had a striking house designed with hallmarks of the southern plantation style. In keeping with the plantation style, a wide veranda surrounded all four sides of the house, and it had an elevated first floor with kitchen, dining and service rooms on the ground floor, along with extremely high thirteen-foot ceilings (highly uncommon in the cold north at the time). Front to back thirty-foot central hallways connected most of the rooms inside. However, the basic style of the house was Italian Villa, bracket-style Victorian, with a square shape, hip roof, tower and roofline brackets on all three levels.

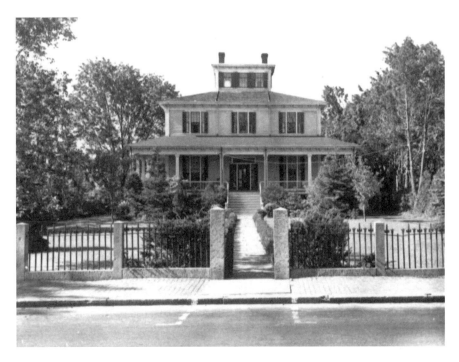

The home of Albert Nye, Falmouth's first noted summer residence. *Courtesy of Falmouth Historical Society.*

A typical feature of Italian Villa style was the square tower on the third floor. A sign of the overall grandeur of the home, it was larger than most cupolas and provided views of Vineyard Sound, which are now obscured by trees. At the time it was built, the house was a wonder to the townsfolk: it possessed a furnace—the only one in Falmouth—and had a private gas plant, as the house and grounds were lighted with gas. The splendid house has been maintained with reverence to its late nineteenth-century origins and currently operates as an inn.

Highfield Hall

Another of Falmouth's elaborate summer residences was Highfield Hall. Boston businessman James Madison Beebe, a leading dry goods retailer and manufacturer, was instrumental in ushering in the town's summer resort era. Beebe rented several houses in town but died before he could build his own estate. Shortly after he passed away, his sons Pierson and Albert set about building on a 668-acre parcel of land their father had acquired on the town's highest hill overlooking Buzzards

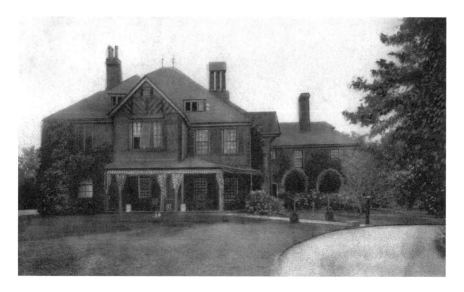

Postcard of the Beebe residence, Highfield Hall. *Courtesy of the Historic Highfield, Inc. Collection.*

Bay. In 1876, Pierson began the process of constructing an English-style country manor house, Highfield Hall. The design of the twenty-one-room house was heavily influenced by the British Pavilion buildings at the 1876 Philadelphia Centennial Exposition. Completed in 1878, Highfield Hall was the earliest known building on Cape Cod to exhibit some of the Pavilion's neo-Elizabethan elements: a cove cornice, a very large living hall and imitation half timbering visible on some of the home's many gables.

Highfield was also one of a scant few examples of the very brief late nineteenth-century period when Stick-style architecture was being assimilated into American Queen Anne. Stick-style buildings were noted for a number of unique features, all united by the use of "sticks," flat board banding and other applied ornamentation in geometric patterns that adorned the exterior clapboard wall surface. Open trusses and braced arches spanned many projecting gables, and houses tended to have asymmetrical floor plans and a color palette of two or three contrasting colors. Queen Anne style, more ornamental and fanciful than Stick style, was characterized by complicated rooflines with steep slopes, turrets, finials and heavily decorated cornices and bargeboards with tall brick chimneys. Queen Anne–style houses also had asymmetrical plans reflective of very busy exterior compositions and could have four quite different sides. Highfield Hall demonstrated this element, as each of the home's four elevations had a different type of projecting bay with different decorative elements. Another hallmark of Queen Anne houses were giant staircases that descended into large entrance halls, from which flowed large comfortable rooms. Highfield Hall also contained this feature. Among the mansion's elaborate first-floor rooms was a ballroom and one of the earliest billiard rooms, which became quite popular in estate houses of the 1880s. The interior of the house featured rich detail and the highest-quality materials of the era. It had sixteen fireplaces, all with exquisitely hand-carved mantels and majolica tile surrounds, gilt sconces, rich mahogany paneling, interior eight-panel doors and several stained-glass windows to add a touch of color and whimsy to the décor.

It is not known for certain whom the architects of Highfield Hall were, but there is evidence to suggest that the revered firm of Peabody &

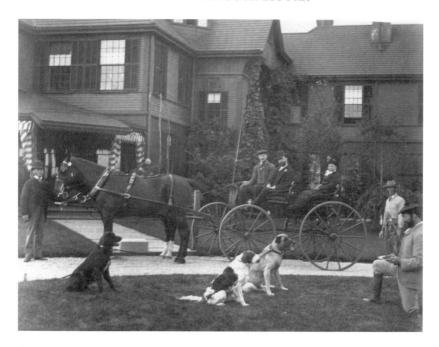

Photo of a family gathering on the front lawn of Highfield Hall. *Courtesy of the Historic Highfield, Inc. Collection.*

An employee stands with a horse and carriage outside one of Highfield's barns. *Courtesy of the Historic Highfield, Inc. Collection.*

One of Highfield Hall's
sixteen detailed fireplaces.
*Courtesy of the Historic
Highfield, Inc. Collection.*

Stearns designed the house. In 1879, Pierson's brother J. Arthur began construction of his own country "cottage" just a few hundred feet away from Highfield Hall, and he definitely contracted Peabody & Stearns to build his Tanglewood, a mix of Georgian and Colonial styles. The Beebe family compound had several auxiliary buildings, formal gardens with special plantings and some fourteen miles of maintained carriage paths and bridal trails that they welcomed the public to enjoy on Tuesdays. The Beebes, who were the largest taxpayers in town, accounting for over 25 percent of the town's tax base, entertained on a grand scale. Boston

"Tanglewood" Falmouth—For Sale

Famous Beebe Estate—Recently the Property of Harvard College—Comprising Main Residence, Stable-Garage, Caretaker's Cottage, Gate Lodge, Greenhouse, Outbuildings and Approximately 30 Acres of Parkland.

WE ARE offering for immediate sale one of the most complete and beautiful summer or year-round estates at Falmouth, Cape Cod, with unobstructed views of Vineyard Sound, and its own private bathing beach.

THE GROUNDS—About 30 acres of elevated parkland heavily wooded, traversed with long gravel drives and planted with spruces, cedars and flowering shrubs, splendidly developed and matured. Magnificent hedges, a tennis court with pavilion, an exquisite terraced formal garden with box bordered paths, and expansive lawns create an atmosphere of lingering charm.

THE RESIDENCE—of dignified and chaste Colonial design, contains on the first floor a large entrance hall, a spacious living room, 40 x 20, with two fireplaces, built-in bookcases, wainscotted in white with grasscloth walls and period electric fixtures. A dining room with fireplace, white wainscotting, Chinese wall paper, built-in buffet and mural fixtures; two reception rooms, a butler's pantry, kitchen and maids' dining room, complete this

floor. The second floor has nine masters' bedrooms and 3 bathrooms. The third floor has seven bedrooms and bath. There are oak floors and fireplaces in principal rooms, heater, and verandas on three sides.

THE STABLE-GARAGE—accommodates 10 horses and several motors.

THE CARETAKER'S COTTAGE—contains 9 rooms and bath.

THE GATE LODGE—has five rooms and bath. There is a greenhouse, tool and equipment house, poultry house and other out-buildings. The bathhouse, with 500-foot frontage on a sandy beach may be purchased with the residence, if desired.

THE WHOLE, a wonderful example of an English country estate at one of the finest ocean resorts on the Atlantic coast. An exceptional opportunity for the person desiring seclusion with close accessibility to station, beach and village, and only 69 miles from Boston, or for Institutional, recreational or scholastic purposes. The price is tremendously low with terms to suit. Permits for inspection from the agents. A full commission paid to co-operating broker.

D. Bradlee Rich & Co.

Commissioners for Uncommon Estates

LIBERTY 5689 24 MILK STREET, BOSTON REALTORS

A real estate advertisement offering Tanglewood for sale in 1927. *Courtesy of Falmouth Historical Society.*

friends and acquaintances came by train regularly, and scores of staff members were needed to attend to their needs and to maintain two such grand residences. Arthur held gargantuan banquets where he instituted an unusual dinner ritual of weighing diners both before and after their meal. At one dinner in 1896, eighteen-year-old Emily E. Beebe increased from 141 7/8 pounds to 146½ pounds.

After the last of the Beebes had passed away in 1932, the houses had a succession of owners. Sadly, Tanglewood succumbed to a wrecker's ball and bulldozers in the 1970s. After a series of unsympathetic alterations that drastically changed the façade, Highfield Hall suffered decades of neglect and vandalism. Gratefully, community support of the historic mansion saved it from demolition in the 1990s, after which a rigorous effort was made to bring the structure back to its original glory. Today, Highfield Hall shines like the gem it was in the nineteenth century. Open to the public for tours and functions, the mansion has been restored to its rare and exceptional architectural origins.

PENZANCE POINT

In 1884, a group of wealthy Falmouth summer residents, led by the Beebes, chartered a private train nicknamed the "Dude Train." The train transported businessmen between Falmouth and Boston during the summer. The trip took an hour and forty minutes, nearly half the time the trip lasted on a regular service train, which was almost three hours. On business days, the Dude Train arrived in Boston by 9:30 a.m. and departed the city at 3:30 p.m. The even easier access to the Cape from the city, coupled with the locale's relaxing seascape, led increasing numbers of the Gilded Age gentry to follow in the Beebes' wake, establishing compounds of their own nearby. A few miles away from the Beebe estate in Woods Hole, Penzance Point was one of the first wealthy enclaves on the Cape. Until the late 1880s, the land on which the luxurious neighborhood arose was owned by the Pacific Guano Company, which made fertilizer from Falmouth menhaden and guano from the Pacific Islands. After the company went bankrupt,

Newton developer Horace Crowell acquired the land from its trustees. Targeting affluent families, Crowell's plan for the waterfront U-shaped neck of land was to create a subdivision of twenty-four lots, ranging from 1.5 to 9.43 acres, served by a single road running its length. Unlike the Falmouth Heights planned community geared to the middle class that had extensive deed restrictions, Crowell had few restrictions on the sale of his lots. He required houses be built for a minimum of $5,000, and only one dwelling house could be built per lot, plus outbuildings. The beaches were to be held in common.

The houses on Penzance Point, named for a town in the Lands End area of Cornwall, England, were large and imposing, emulating English manor houses built in grandiose historical revival styles such as Tudor and Georgian. Most were surrounded with outbuildings, including stables and boathouses, and many had private tennis courts. The subdivision became known as "Bankers Row" after Seward Prosser, the head of J.P. Morgan's Banker's Trust in New York City, built a magnificent summer estate and persuaded some his banking associates to join him. Notable residents included the chairman of the Federal Reserve Bank of New

The Dude Train allowed for an hour-and-forty-minute commute between Boston and Falmouth. *Courtesy of Historic New England.*

York, the managing director of Singer Sewing Machine and the Crane paper family of Dalton, Massachusetts. Nearby at Nobska Point, the British ambassador even summered for a time.

Wheelwright House

Just outside of Penzance Point, Chicago resident Mahlon Ogden Jones, president of the Southern Pacific Railroad, constructed a stunning summer retreat in 1888. The fifteen-thousand-square-foot manse was built in the Shingle style, a popular design of coastal estates built during the era characterized by lack of symmetry, rich and varied siding textures, windows of varying sizes and style and elaborate wood trim. Built upon stone bases, wood-frame Shingle-style houses were horizontal, rambling and casual—reflective of the purpose they served: to provide a relaxing seaside haven. Jones's house was designed by Boston architect Edmund March Wheelwright, who played a significant role in steering American residential architecture away from Queen Anne style to the Shingle style. Before opening his own practice, Wheelwright worked for the highly regarded firms of Peabody & Stearns and McKim, Mead, & Bigelow.

Located two hundred yards inland from Vineyard Sound, the house had a commanding view of Martha's Vineyard and the Elizabeth Islands, and many porches framed the spectacular vista. The house featured a multi-gabled roof, with tall chimneys incorporating numerous chimney pots. Elaborate interior detailing included twenty-five different types of molding and carved plaster ceilings and fluted columns supporting decorated beams in the major living spaces. Windows were made of German-blown leaded glass, and many of the nickel- and brass-plate sink fixtures were imported from Quebec. All of the home's millwork was done in Boston, shipped by train to Woods Hole and taken by horse cart to the site. The house also featured three hundred feet of copper guttering, which was a massive expense during that era.

Although a fire severely damaged the house in 1986, the current owners painstakingly rebuilt it according to its original nineteenth-century specs, right down to hand-blocked wallpapers and lighting fixtures. The

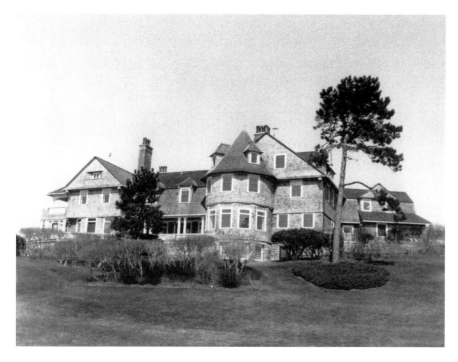

The Shingle style Wheelwright House. *Courtesy of Woods Hole Historical Collection and Museum.*

house contains original bronze sconces on the first floor, along with rugs designed by Wheelwright. Some of the original sink fixtures survived the fire, and replicas were located for those that were destroyed. The home's leaded-glass windows were also replicated, and the mantels of the eleven fireplaces are carved as they were in Jones's day.

BREWSTER'S ELITE RESIDENCES

While prosperous communities were heavily concentrated on the Upper and Mid-Cape, wealth also spread to some areas of the Lower Cape, including the small town of Brewster, bordered on the north by Cape Cod Bay. Among the town's fine summer estates was that of prominent native Samuel M. Nickerson. One of the most influential business leaders of the late nineteenth century, Nickerson left Brewster in 1847 to seek

his fortune. By 1863, he was president of the First National Bank of Chicago, a position that would enable him to acquire massive wealth. According to a *New York Times* article in September 1899, Nickerson's shares in First National Bank of Chicago were sold for $2.1 million. The syndicate that purchased the shares included J.P. Morgan, E.H. Harriman and Marshall Field.

Nickerson returned to Brewster for summer respites, and in 1890, he built a glorious shingle and fieldstone summer house. Located on a knoll along the edge of the ocean, the estate was named Fieldstone Hall and boasted a large carriage house, windmill, nine-hole golf course and a two-thousand-acre game preserve. The public was prohibited from hunting and fishing on the game preserve, which the WPA guide *Cape Cod Pilot* called "a slice of the Cape big enough to compare with the holdings of old feudal barons." The Nickersons hosted many enchanting social events, and upkeep of the estate required a staff of twenty-two employees.

After Samuel and his wife passed away, their son Roland, also a wealthy Chicago businessman, and his wife, Addie, took over Fieldstone Hall. In 1906, a fire burned the home to its foundations, and the house was rebuilt

Postcard of Samuel Nickerson's lavish summer residence, Fieldstone Hall. *Courtesy of the author.*

in even greater splendor. Completed in 1912, the mansion incorporated some features from the original version, yet its architectural style reflected the attitudes of the 1900s rather than the Victorian 1890s. The house emulated the style of English country manors with an eclectic blend of Renaissance, Revival and Gothic themes. The house included an intricately carved, imported Italian oak staircase, Edwardian fireplaces in marble and carved wood, sterling silver wall sconces, leaded-glass windows, tiered chandeliers and a number of outdoor terraces. Upon Addie's death, the game preserve was donated to the commonwealth and it became the first Massachusetts state park, called Nickerson State Park. Fieldstone Hall is now part of the Ocean Edge Resort and Conference Center.

Tawasentha

Just down the road, another fantastic Brewster mansion was built by a native Brewster resident, Albert Crosby, who also made his fortune in Chicago. After cashing in on the 1849 gold rush, Crosby went on to establish a wildly lucrative wholesale tea and liquor business in the 1850s. He later acquired the Crosby Opera House, considered the most magnificent opera house in the West. After divorcing his first wife, Crosby married one of the opera house's young entertainers, Georgia T. Garrison, who was also known as Matilda. The two traveled extensively through Europe for a decade before returning to Brewster, where Crosby set about constructing a glorious summer home for his wife in 1887. Named Tawasentha, a word taken from his friend Henry Wadsworth Longfellow's poem "Hiawatha," the house featured elements of the Queen Anne style and was a combination of complex gables, dormers, clustered chimneys and broken pediments with Grecian urns on top. The house was surmounted by a sixty-foot-high tower, from which there was an inspiring view of Cape Cod Bay and a large portion of the inside shore of the Cape. Featuring the latest plumbing and heating technologies, the mansion had a steam-heating apparatus and was lit by gas. The gas supply was manufactured in the basement, along with the engine and pumps that provided the water supply.

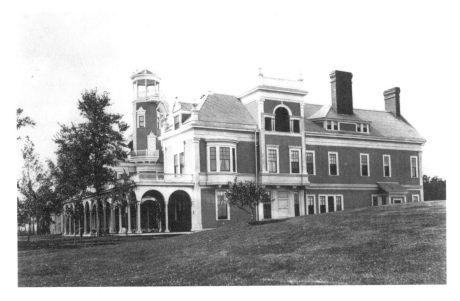

Front exterior shot of Albert Crosby's gracious residence, Tawasentha. *Courtesy of the Brewster Historical Society.*

Tawasentha was built on the plot of land where Crosby had grown up, and to pay homage to his origins, he incorporated the modest 1832 Cape Cod–style home of his boyhood into the new manse. One could walk directly from the front hall of the mansion—inspired by a room the Crosbys had visited at Buckingham Palace—through elaborately paneled doors into the old house. Matilda entertained lavishly, welcoming a glittering crowd from the artistic and theatrical circles of London, Paris, New York and Chicago, and it is said that when the parties became too much for him, Crosby retired to his old homestead. Built by John Hinckley and Sons, he hired the most skilled craftsmen on the Cape, as well as a few imported workers, to do the detail and ornamental work. So great was the undertaking that the Old Colony Railroad laid a sidetrack to the construction site.

The mansion had thirteen fireplaces, all different, with tiles imported from England. A sweeping spiral staircase crowned with intricate balusters led to the upper floors. Among the home's airy living spaces was a billiard room finished in gold oak with a separate entrance and massive fireplace that was meant to resemble an Adirondack hunting lodge. A

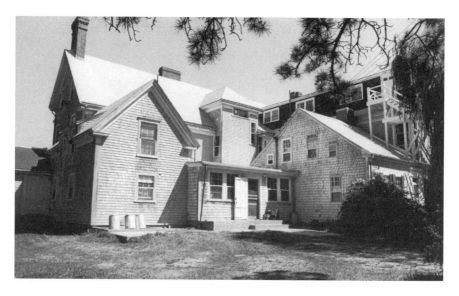

Back view of Tawasentha that shows Crosby's boyhood home incorporated into the structure. *Courtesy of the Brewster Historical Society.*

library was paneled in imported Indian mahogany, and walls were covered with anaglypta, a fragile material composed of hard and soft paper in layers, pressed to give a decorative relief, finished with gold leaf. An extensive south wing housed a seventy-five- by fifty-foot art gallery that accommodated a valuable art collection the Crosbys had acquired during their years in Europe. The collection included works by El Greco, Jean Francois Millet and Albert Bierstadt. Huge paintings covered the walls, smaller ones stood around the long room on easels, marble busts were perched on small tables and there were dainty chairs and sofas all around the room on which one could perch to take in the vast amount of artwork. While throughout the house there were windows of every size and shape to let in light at every turn, the art gallery had no windows except for a ring of skylights in the stepped back roof, which let in bright daylight without harming the artwork.

An 1892 valuation estimated the mansion's worth to be $25,000, quite an amount for the time period. Crosby lived in the house until his death in 1910, and Matilda resided there until 1928. Upon her death, most of the contents of the house were auctioned off for a song. Just weeks

View of Tawasentha's curved staircase railing from the second floor. *Courtesy of the Brewster Historical Society.*

Intricate sconces and hand-blocked wallpapers were found throughout the mansion. *Courtesy of the Brewster Historical Society.*

before the stock market crash of 1929, an art auction gathered a crowd of hundreds. The collection of 148 paintings, plus sculptures and bric-a-brac, was valued at over $100,000, yet the sale brought in a paltry $6,000. The house had a succession of owners. It became a music conservatory, a hotel and restaurant and a camp for overweight girls. After a prolonged period of vacancy, the property suffered greatly by vandals and vermin and became a dilapidated mess. In the 1990s, however, a rescue mission began when the Friends of Crosby Mansion was formed, dedicated to restoring the mansion. Now part of Nickerson State Park, the house is well on its way to resurrecting its graceful past. Significant restoration has been done—elaborately carved tables and rich paneling abound, original mirrors gleam and the prominent winding staircase easily recalls the grandeur of the Crosby era—and the public is welcome to tour the property seasonally.

Gray Gables

Among the dignitaries who were establishing estates on Cape Cod in the later half of the nineteenth century was President Grover Cleveland. In fact, his presence did much to elevate the region's cache as a high-class summer haven. In 1889, after he finished his first term as president of the United States, Cleveland created his personal summer retreat on the far end of Buzzards Bay in Bourne. Drawn to the area for its solitude and natural setting, President Cleveland, a great sportsman who loved to fish, purchased 110 acres of rolling land surrounded by a heavy woodland of pines, oaks and cedars, with commanding knolls and one and a half miles of beachfront. Cleveland purchased the estate, which he named Gray Gables, for $20,000. There was a hunting lodge on the property that he kept intact, and he opted to rebuild the existing house on the property into a twenty-room Shingle style mansion with many gables and open porches that wrapped around the entire house.

When asked by the *Boston Globe* why he chose Buzzards Bay, Cleveland responded:

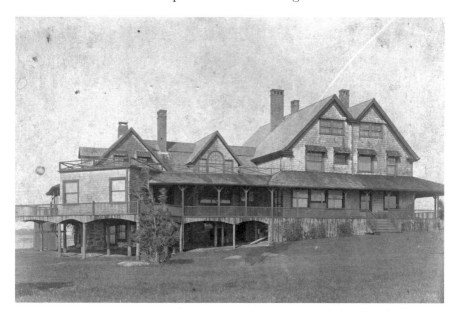

Exterior shot of Grover Cleveland's Gray Gables. *Courtesy of the Bourne Archives.*

I come to Buzzards Bay to spend my vacation because of all the places within my knowledge it is the most comfortable and convenient. So far as my location is concerned extreme summer heat is unknown. Boating and bathing are all that could possibly be desired, and the drives about me are full of interest. The fishing which to me is a most important consideration, is excellent. All manner of sea fishing is near at hand and when one tires of that he has but to turn his back to the sea and within easy reach are numerous fresh water ponds where all sorts of fresh water fishing is to be had. I like my residence too, because my neighbors are of that independent sort who are not obtrusively curious. I have but to behave and pay my taxes to be treated like any other citizen of the United States.

In 1892, a telegraph instrument was installed at Gray Gables to record the proceedings of the Democratic National Convention in Chicago. On September 24, a group of friends gathered with the Clevelands to await the outcome. It was near sunrise before the nominations were finished, and Cleveland was nominated by a landslide. That November, he was

The Gray Gables Train Station. *Courtesy of the Bourne Archives.*

elected the twenty-fourth president of the United States. During his second term in office, Gray Gables became the summer White House. A private railroad station was established near his home with the primary purpose of transporting Cleveland to and from Washington, D.C., in an expedient manner.

The Secret Service agents who surround the comings and goings of presidents and even an ex-president today had no counterpart in Cleveland's time, so there was no entourage dictating the course of Cleveland's summer days. In Bourne, he was very much a man of the people. He was simple and unpretentious, entirely approachable. He refused to let photographers take photos of Gray Gables. He preferred that life at Gray Gables be simple and filled with time spent with his family, though Cleveland and his wife, Frances, did host a few glamorous events at the house and he invited his political friends for extended stays. He also

enjoyed the company of his neighbors, who included the actor Joseph Jefferson, well known for his role of Rip Van Winkle. Cleveland spent summers at Gray Gables until the untimely death of his daughter Ruth (for whom the candy bar "Baby Ruth" was named) in 1904; the thought of spending time at Gray Gables without her was too devastating. The family sold the estate in 1921, and much of the land was parceled into small lots and redeveloped. The mansion became an inn and restaurant, which sadly burned to the ground in the 1970s.

Chapter 5

EMBRACING THE

TWENTIETH CENTURY

Cape Cod entered the twentieth century as an established summer community. A *New York Times* article by R.H. Cahoon in September 1912 depicted the region's summer atmosphere:

> *The summer population of Cape Cod may not represent such exclusive social circles as Bar Harbor or Newport. The people who go there seek a complete rest, and do not keep up an endless series of fashionable teas, fetes, and dinners. It is what may be called truly the ideal place for a vacationist—any one who, through the necessity of constant work in noisy cities, needs a quiet restful nook for several weeks sojourn. People go down to Cape Cod from New York by the hundreds. In fact, nearly every little village resort on the Cape is able to boast of some family New York for the summer season. But the summer visitors to the Cape do not all come form New York. Instead, whole families come from various parts of the United States and Canada. California, Washington, and some of the large Canadian cities have representative summer colonies here. Philadelphia, Chicago, Boston, St. Louis, and Cleveland do their share toward sending people and trunks toward Cape Cod for June, July, and August.*

The article continued: "Time was, a score of years back, when the land in certain parts of Cape Cod was almost worthless. It could be bought

for as low as a dollar an acre, this same land now is being sold for several hundred dollars an acre. The reason is that these spots, ideal situations on the seashore, are increasing in popularity year after year."

While residential designs continued to reflect the styles exhibited throughout the later half of the prior century, some of the architecture of elaborate estates was more adventurous. In contrast, humble cottages continued to offer relaxing respites for the middle classes.

The Airplane House

In 1910, wealthy Chicago industrialist and philanthropist Charles R. Crane purchased a sprawling 1880s Queen Anne–style summer home in Woods Hole. Crane, who would become Woodrow Wilson's financial backer in the 1912 presidential election, hired the Chicago-based progressive architectural practice Purcell & Elmslie to renovate the house and design a series of outbuildings. In 1911, Crane commissioned the firm—which was the second most commissioned firm of the Prairie School, after Frank Lloyd Wright—to design a bungalow for his daughter, Josephine Bradley, and her family. The works of the Prairie School architects, built primarily in the Midwest, were usually marked by horizontal lines, flat or hipped roofs with broad overhanging eaves, windows grouped in horizontal bands, integration with the landscape, solid construction, craftsmanship and discipline in the use of ornament. Horizontal lines were thought to evoke and relate to the native prairie landscape.

While the family initially envisioned the structure to be a three-room portable cottage that could be built for a mere $600, they soon realized that their needs required a much bigger home with modern amenities, and they encouraged the firm's principals, William Gray Purcell and George Grant Elmslie, to design a house with Prairie style sensibilities. The architects eagerly embraced the challenge of creating a Prairie style house on Cape Cod. The Cranes selected the most elaborate of three proposed schemes that Purcell and Elmslie devised: a home with four principal bedrooms, two large sleeping porches, several bathrooms, an

enormous living room, kitchen, two dining porches, open terraces and servants' quarters.

The house was based on a sophisticated cruciform scheme with wings projecting from a central core and two wings astride, stretching more than one hundred feet from tip to tip in one direction and eighty feet in the other. Located on a peninsula and positioned to maximize the views of Woods Hole Harbor on one side and Vineyard Sound on the other, every room in the five-thousand-square-foot house had a sea view. To protect against the hurricane-force winds that often swept the location, the house was framed structurally with iron vertical boards anchored in cement that reached eighteen feet into the earth.

The home's semicircular living room, with its fifty-two-foot diameter, projected like a pilot house to command the views and defined the building's shape. The room exemplified the open plan feel of the house. In addition to a massive fireplace crowned by a fan of tapered Roman

William Gray Purcell and George Grant Elmslie's Prairie-style Airplane House. *Courtesy of Northwest Architectural Archives, University of Minnesota Libraries.*

Ground-floor plan rendering of Airplane House. *Courtesy of Northwest Architectural Archives, University of Minnesota Libraries.*

brick, the room featured a continuous band of art glass windows—of which no two were alike. A typical feature of many Prairie-style homes, art glass windows were used to ensure privacy and to allow for an absence of curtains. Constructed of leaded glass with colored panes and geometric patterns, each window revealed a slightly different pattern. While the windows were inoperable, they framed the ocean view spectacularly.

The living room featured soaring ceilings with open beams and joists that were not only functional but also decorative. On the second level, windows were also art glass and walls were clad in cypress board and batten. Throughout the house, built-ins predominated: there were desks, bureaus, bookcases and dressing rooms, and hallways contained many closets, cupboards and built-in drawers. Elmslie designed the majority of furnishings, which included not only tables, chairs and couches but also switch plates, copper lighting fixtures and faucets.

Right: Architect sketch of the home's art glass windows. *Courtesy of Northwest Architectural Archives, University of Minnesota Libraries.*

Below: View capturing the living room's rich paneling, soaring ceilings and open beams and joists. *Photo by Dan Cutrona.*

Despite the enormous amount of work required to build the home and detail the interiors, the architects and their building team had from April 1 to October 1 to create the structure. Purcell recorded his experience on the project:

> *The work was naturally a high pressure job all summer. We made several trips, and Mr. Elmslie spent several weeks there in superintendence. One of the more interesting aspects of the job was that Mr. Crane was in Europe and Mr. and Mrs. Bradley were in California, and none of them ever saw the work from the time the preliminary sketches were approved until they walked into the completed building October first. We not only constructed the building, developed the landscaping complete, but on my last trip in August, we placed local orders for all equipment for the house, furniture, rugs, linen and bedding all monogrammed, correspondence paper, and minor gadgets of every kind, kitchen equipment, curtains and so on, no end.*

The Cranes and Bradleys were delighted with the house, which ended up costing $30,000—a far cry from the original concept of the $600 bungalow. However, the neighbors were none too pleased with the seaside bungalow. They demanded Crane tear it down and derisively nicknamed it "Airplane House" because of its appearance. According to Purcell: "Rumors of savage comments on this outrageous and radical departure from New England tradition led Mr. Crane at one period to take a special trip to Woods Hole to see what the furor was all about. He wired Mrs. Crane his pleasure in stating that the house took its place beautifully." In his own opinion about the house, Purcell remarked, "The bungalow was only startling because its forms were new. Basically, it grew out of its environment with perfect naturalness and simplicity." While it received opposition at the outset, the house is now a much beloved landmark in the area. Privately owned, the house was recently restored to its origins, a process that required a great deal of precision, patience and perseverance. Clad with weathered cedar shingles and sporting blue trim, the home's exterior mirrors its early twentieth-century appearance. The interior layout, woodwork and art glass windows remain intact,

and much of the furniture is original; artisans were commissioned to reproduce replicas of other items. The house is a treasured testament to the architecture of another era.

AN ARTISTS' PARADISE

At the turn of the century, inspired by European art colonies, summer schools of art were being established throughout the United States. About this time, as artists began to see the appeal of Cape Cod, they were drawn to its magically luminous light and unspoiled landscape, along with the area's laidback atmosphere. Summer painting schools were established on the Outer Cape, primarily in Provincetown. The Cape Cod School of Art, founded in 1899 by Charles W. Hawthorne, an American Impressionist painter, was the most famous. On Provincetown's waterfront, Hawthorne taught his students, who came from all over the country and went on to become fine landscape as well as abstract artists, to paint directly from nature.

On August 27, 1916, a headline in the *Boston Globe* read "Biggest Art Colony in the World at Provincetown." More than three hundred artists and students were in town, and six schools of art were in operation. Expatriate artists who had been studying and working in France returned, fleeing the war. At the same time, there was an influx of poets, novelists, journalists and playwrights as well as artists from New York City's Greenwich Village and other cities, who brought a bohemian lifestyle to the Cape with them. A theatre scene developed in 1915 with the Provincetown Players, launched by a group of writers and artists who wanted to see a change in American theatre. The company, founded by Susan Glaspell and her husband, George Cram Cook, was committed to producing new plays by exclusively American playwrights. Along with Susan Glaspell, Eugene O'Neill was one of the most influential playwrights to join the Provincetown Players, and he would go on to write such successful and acclaimed plays as *The Iceman Cometh* and the Pulitzer Prize–winning *Beyond the Horizon*.

The Dune Shacks

Artists and writers relished the creative community they experienced during the Cape Cod summer; they shared ideas and criticism with one another. In addition to the camaraderie, creative types headed to Cape Cod in search of inspiration and, sometimes, for solitude. Most were not interested in living in grand summer mansions, instead preferring to spend the season in simple cottages. Starting in the 1920s, many writers and artists took to inhabiting small, rustic shacks interspersed among the dunes of Provincetown near the Peaked Hill Bars Life Saving Station. The shacks, situated along a three-mile stretch of incredible dunes anchored by a thin layer of beach grass from Race Point to High Head in Truro, were first built in the 1800s by the Humane Society in conjunction with lifesaving efforts. Surfmen watched the offshore shoals for ships in distress, rescuing people shipwrecked by storms and offering them shelter in the shacks.

A Description of the Eastern Coast of the County of Barnstable, published in 1802, pointed out the spots on which the Humane Society had erected huts called "Charity" or "Humane Houses." "Each hut stands on piles, is eight feet long, eight feet wide, and seven feet high; a sliding door is on the south, a sliding shutter on the west, and a pole, rising fifteen feet above the top of the building is on the east. Within it is supplied either with straw or hay, and is further accommodated with a bench." Thoreau discovered the shacks on his travels, and while he approved of the general concept of the Humane Society's lifesaving huts, he was not too impressed by the accommodations in the one hut he examined:

> *Keeping on, we soon after came to a Charity-house, which we looked into to see how the shipwrecked mariner might fare. Far away in some desolate hollow by the sea-side, just within the bank, stands a lonely building on piles driven into the sand, with a slight nail put through the staple, which a freezing man can bend, with some straw, perchance, on the floor on which he may lie, or which he may burn in the fireplace to keep him alive. Perhaps this hut has never been required to shelter a ship-wrecked man, and the benevolent person who promised to inspect*

it annually, to see that the straw and matches are here, and that the boards will keep off the wind, has grown remiss and thinks that storms and shipwrecks are over; and this very night a perishing crew may pry open its door with the numbed fingers and leave half their number dead here by morning...These houses, though they were meant for human dwellings, did not look cheerful to me. They appeared but a stage to the grave. What kind of sailors' home were they? This "Charity-house," as the wrecker called it, this "Humane-house," as some call it...had neither window nor sliding shutter, nor clapboards, nor paint. As we have said, there was a rusty nail put through the staple. However, as we wished to get an idea of a Humane-house, and we hoped that we should never have a better opportunity, we put our eyes, by turns, to a knot-hole in the door...We discovered that there were some stones and some loose wads of wool on the floor, and an empty fireplace at the further end; but it was not supplied with matches, or straw, or hay, that we could see, nor "accommodated with a bench." Indeed, it was the wreck of all cosmical beauty there within...However, we were glad to sit outside, under the lee of the Humane-house, to escape the piercing wind.

As lifesaving personnel moved to more solid facilities, the shacks were discovered by artists and writers, who were enamored by the promise of quiet summers by the beach. By that time, the shacks varied slightly in size and design, but all were rustic and weathered, devoid of electricity, running water and toilets, with no modern conveniences whatsoever. Playwright Eugene O'Neill was the first writer to make his summer home in the dunes, working from the old coast guard station at Peaked Hill during the First World War. He lived there for a number of years with his wife, Agnes Boulton. O'Neill's shack was the anchor of Provincetown's art community, playing host to some of the greatest minds of its day: novelist John Dos Passos, critic Edmund Wilson and fellow playwright Susan Glaspell were among its regular visitors. Other poets, painters and writers followed O'Neill to the Spartan environment the Provincetown dunes offered, and among the shacks' inhabitants were poets e.e. cummings and Mary Oliver; painters Edwin Dickinson, Boris Margo, Willem de Koonig and Jackson Pollock; and authors Jack Kerouac and

The Margo Gelb dune shack in Provincetown. *Photo by Christopher Seufert.*

Norman Mailer. Many published accounts of their experiences living among the dunes, including Harry Kemp, self-titled "poet of the dunes," who wrote exhaustively of the habitat's ethereal beauty, and Hazel Hawthorne-Werner, who authored *The Salt House* (1929), an account of her adventures in the dunes.

With the formation of the Cape Cod National Seashore by Congress in 1961, the National Park Service asserted that the dune shacks did not qualify for private ownership within the park. In an effort to preserve the dune shacks and their traditional uses, owners pushed back. The Seashore responded by setting termination dates for each shack owner through "reservations of use." In the majority of cases, under settlements between the owners and the federal government, the park issued either a transferable twenty-five-year use (a time estate) or a non-transferable lifetime use based on certain occupants (a life estate). During the period, the people holding the reservation were legally permitted to determine who used the shack, within specified parameters. When the terms of each reservation ended, the legal right to use the shack ended.

As some terms began to expire in the 1980s, the struggle to legally preserve the dune shacks and their traditional uses by dune dwellers saw a revival. The effort eventually led to recognition by state and federal agencies that the dune shacks had values of historic nature. Based on the noted literary and artistic figures who inhabited the shacks during the twentieth century, they had earned a place on the National Register of Historic Places, an appellation that preserves their existence and use for future generations. The seventeen remaining cottages are collectively known as the Peaked Hill Bars Historic District. While one cottage is privately owned, most have long-term lease agreements with the park service. Some of the leases are held by families, while several have been obtained by nonprofit organizations.

The Peaked Hill Trust makes some of the shacks accessible to a wide variety of people who, by lottery, may rent them by the week in the summer. Some shacks continue to cater to creative types by providing shelter for artist and writer residencies. Among these cottages is the Margo-Gelb shack, a one-room shelter without electricity or running water, located just a few hundred feet away from the Atlantic Ocean and a mile, mostly over sand, away from town. The shack contains two single beds, a bench, chairs and table, kerosene lamps, a dry sink, a small gas stove, a small gas refrigerator and an outhouse. The pump for water is a short walk away. C-Scape is another shack available to the public. With conveniences including a propane cooking stove, small refrigerator and a composting toilet, the primitive nature of the one-and-a-half-story, three-room structure and its physical isolation allow for uninterrupted solitude and refuge.

OTHER BEACH COTTAGES

More writers and artists built their own small havens in other areas by the dunes or along the shoreline of the lower and outer Cape throughout the early twentieth century. One such writer was Henry Beston, who retreated to Eastham's outer beach in search of serenity and solitude during the spring of 1925. On the beach, two miles south of the Nauset

Coast Guard Station, he had a twenty- by sixteen-foot wood frame cottage built. In September 1926, Beston, thirty-eight years old and single, went for a two-week vacation to the cottage he had dubbed the "Fo'castle." He had not intended to stay, but as he recounted later in his book *The Outermost House*, "The fortnight ending, I lingered on, and as the year lengthened into autumn, the beauty and mystery of this earth and outer sea so possessed and held me that I could not go." Thus began a solitary sojourn on the beach. Published in 1928, *The Outermost House* brought that place, that year to life for legions of devoted readers. Considered one of the fathers of the modern environmental movement, his lauded book has been credited as a motivating factor behind the creation of the Cape Cod National Seashore.

After marrying writer Elizabeth Coatsworth, the couple moved to Maine. Beston donated the "Fo'castle" to the Massachusetts Audubon Society in 1959 and made one last trip there in 1964 when the house was dedicated as a National Literary Landmark. Writer Nan Turner Waldron, who spent several weeks each year there from 1961 to 1977, chronicled her experiences in the book *Journey to Outermost House*. During a winter hurricane in 1978, the house was carried away by astronomically high tides. Years later, Waldron wrote that thousands still came to the beach each year wanting to learn more about this man who retreated to the outer beach "in a search for the great truth, and found it in the spirit of man. Many know the book, some carry it with them," Waldron wrote. "Still they come, pilgrims of a sort—stirred by his sense of wonder but drawn by his vision of hope."

Edward Hopper, one of the most original and important realist painters of the twentieth century, was deeply inspired by the Cape Cod landscape. Among the more than 2,500 works he created before he died in 1967 are countless scenes capturing the Cape's untamed, fragile beauty. On the Cape he found movement and drama in the interplay of solitude, architecture and light. His paintings of the area depicted seaside cottages, pitched-roof saltboxes, fishermen's shacks, churches and lighthouses. Hopper and his wife, fellow artist Josephine Nivision, lived frugally, and for most of their married life, the couple occupied the same New York City fourth-floor walk-up that didn't have central heat until the

Postcard of writer Henry Beston's cottage, the "Fo'castle." *Courtesy of the author.*

1960s. For years they lugged coal up on a dumbwaiter for their potbelly stove and even shared a communal bathroom.

In 1930, the couple discovered Truro. Hopper, who was deeply private and prone to depressions, found the town to be "much less spoilt than a lot of the Cape." At the time, five hundred people lived in Truro, a rolling stretch of land between Provincetown and Wellfleet, year-round. Hopper spent forty of his eighty-four summers in Truro. In 1934, with a small inheritance Josephine received, the couple built a modest white clapboard cottage that sat on the backbone of a bluff called Hogs Back overlooking Cape Cod Bay, amid thirty acres of undeveloped rolling grassland. The house overlooked the small evergreen shrubs of bearberry and broom crowberry, dune grass and an empty stretch of Fisher Beach where Hopper liked to swim. "It's just a summer cottage, as primitive as the land it's in," Josephine once wrote to a friend. Like Hopper's paintings, the eight-hundred-square foot cottage was simple, pared down with gray floors and white walls. Like the dune shacks in Provincetown, there was no telephone, electricity or refrigerator until 1954. The cottage's one embellishment was a huge, thirty-six-paned north-facing window that

embraced the changing light, with sweeping views of the land and sea. Today, the house is privately owned and remains relatively unchanged from the way it was when Hopper lived there. Due to the efforts of ardent conservationists who wish to preserve the view Hopper had from his home, the thirty-acre swath stretching north remains mostly untouched, with only the tops of a few new homes visible.

Chapter 6

MODERNIST RESIDENCES

As World War II drew to a close, Modernism was taking hold in America. Important architects of the Bauhaus—the German movement that stressed simple, functional designs blended with artistry— had fled to the United States. Nazi propaganda had cast modern architecture as degenerate, brute and Semitic; in contrast, America embraced architectural Modernism as progressive and democratic. Many of these early Modernists made their way to Massachusetts, including Walter Gropius and Marcel Breuer, who both became professors at the Harvard School of Design. They designed houses in Boston suburbs with flat roofs, cubic shapes and open floor plans.

OUTER CAPE BECOMES A LABORATORY FOR MODERNIST ARCHITECTS

In the early 1940s, Jack Phillips, an acolyte of Gropius, envisioned a Modernist outpost on the Outer Cape. The young Bostonian had inherited eight hundred acres of ocean-side woodland in Wellfleet, and he began building a series of small, lightweight houses. Locals referred to the houses as "paper houses"—and some people were suspicious that the foreign structures were somehow being used to signal German U-boats lingering offshore. After the

war, Phillips persuaded many prominent Modernist architects—including Breuer, Serge Chermayeff, Paul Weidlinger, Nathaniel Saltonstall and Oliver Morton—to build summer cottages in the area. Architects found that the Cape was an ideal place to experiment with their designs. They were enticed by the region's pristine environment and undeveloped land that was available for modest sums. In some cases, lots cost as little as $1,000, and the architects could build houses for as cheaply as $5,000.

On the Outer Cape, architects could build very close to nature and have an artistic way of life. The Modernist cottages were built predominantly in Wellfleet—many within the Cape Cod National Seashore—as well as in Provincetown and Truro, throughout the 1940s, 1950s and 1960s. Nestled by thick scrub pines, overlooking salt ponds, inlets and sand dunes, structures were oriented to capture views and breezes and to integrate with the outdoors. The tiny houses were humble in budget, materials and environmental impact. They were airy and informal, with few frills, exemplifying the concept that a lot of material things were not necessary to live happily. Designed to sit lightly on the land, "The houses were 'green' structures well before 'green' was the big thing," says Peter McMahon, executive director of the Cape Cod Modern House Trust, a nonprofit devoted to documenting and preserving the Modernist architecture on the Outer Cape. "They were small, built low to the ground, and designed to sit in the landscape. They didn't overpower the setting, or stick up into other people's views, which is what you often see with new construction now."

While the houses were intended to be rustic, a lot of thought went into building them. "The designs were very intentional. There's a lifestyle implied by these buildings, one that recognizes the importance of nature, creativity, and sustainability," says McMahon.

Architects used the remote stretch of the Outer Cape as a laboratory where they could explore the fundamental ideas about shelter. They studied the structural and weathering characteristics of wood and experimented not only with different types of wood but also with concrete and homasote, the first building material made from recycled consumer waste. Hallmarks of the Modernist cottages included flat roofs, boxlike shapes and expansive windows and doors designed to let in as much natural light and views of the setting as possible.

MARCEL BREUER

Marcel Breuer was among the most internationally acclaimed architects to build on the Outer Cape. In Germany, he was a master furniture maker, and his experiments in tubular steel revolutionized furniture design. After coming to America, his residential designs became very popular on postwar modern houses. Among his numerous large commissions was the design of the Whitney Museum of American Art in New York City. Breuer arrived in Wellfleet in 1944, where he bought a pond-front parcel of land from Phillips. He developed a prototype for a simple vacation house that consisted of a simple, shed-roofed volume with tongue and groove cedar siding over plywood and a roofed, screened porch and sun shade suspended from cables. Breuer designed a house for himself and one for his close friend and MIT professor Gyorgy Kepes based on this prototype, along with two other similar houses in Wellfleet. He planned a community of five to seven

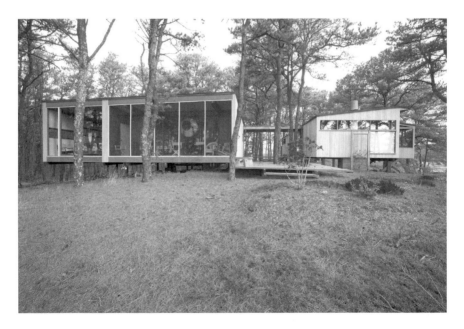

A Marcel Breuer–designed cottage in Wellfleet, sited to maximize views and sit lightly on the landscape. *Photo by Bill Lyons.*

others based on his prototype, but it was never realized. Built with off-the-shelf materials, his houses had a sculptural quality, were humble in scale and were sensitively sited to maximize the landscape. Breuer and his wife spent summers in Wellfleet for the rest of their lives. After retiring in 1976, he died after a long illness in 1981. The architect is buried behind his beloved Wellfleet home.

SERGE CHERMAYEFF

A close contemporary of Breuer's was Serge Chermayeff. Born in what is now the Chechen Republic, Chermayeff was educated in England. Following a brief stint as an interior designer, he formed an architectural firm with German architect Erich Mendelsohn. A decade later, Chermayeff was working as an architect in the United States. He became chairman of Brooklyn College's architectural department and was later the president of the Institute of Design in Chicago. Until his retirement in 1970, he held positions at Harvard, Yale and MIT. Like Breuer, Chermayeff arrived in Wellfleet in 1944, where he purchased a small cabin on twelve acres of land for $2,000 from Phillips. Over several years, he transformed the site into a family compound with a studio where he could pursue his great passion: painting. The frame of the main house was made of diagonal braced two- by ten-foot boards, with light panels in-filled with brightly colored homasote crossed with strapping. An open porch overlooked vast woodland. Over time, the porch was enclosed, the homasote was replaced with clapboard and the colors became more muted. Interested in exploring the expressive possibilities of the post-and-beam frame, he designed at least ten more houses and commercial structures on the Outer Cape. He spent time at his beloved home in Wellfleet until his death in 1996.

JACK HALL

A close friend of Jack Philips, Jack Hall was a Princeton graduate who moved to Wellfleet in 1937. For $3,500, he bought an old farm compound spread out on 180 acres from writer John Dos Passos's wife, Katie. A self-taught designer and builder, he had his own design practices in both Wellfleet and New York City, where he also instructed at Parsons School of Design's Industrial Design Department. Hatch's most intriguing project was the Wellfleet cottage he designed for the editor of the *Nation* magazine, Robert Hatch, and his wife, Ruth. Located on a fabulous perch in the dunes overlooking Cape Cod Bay, the minimalist summer cottage was conceived as cubes in a grid matrix. The house, built in 1960, had three separate units in a three-dimensional grid: the living room/kitchen, two bunkrooms and the master bedroom and studio. Hall's plan allowed for the exterior walls to be winched up to expose glass and screen panels that opened up to covered verandas that wrapped around the house. Surrounded by vegetation, the structure hovered just a few feet above the landscape— so much a part of its setting that it was barely discernable where the boundaries were between the indoors and out.

PAUL WEIDLINGER

Not far from Breuer's house in Wellfleet, Paul Weidlinger built his own summer haven in 1953. Weidlinger, who apprenticed with Le Corbusier, one of the pioneers of Modern architecture, was an innovative structural engineer. He collaborated with architects all over the world on major commissions and worked with artists such as Pablo Picasso, Jean Dubuffet and Isamu Noguchi to create large outdoor sculptures. An adjunct professor at MIT and Harvard University, he did pioneering work in earthquake and blast-resistant buildings. Weidlinger's close friend, Breuer, along with Gropius and Le Corbusier, all gave him advice on the design of his summer house. Le Corbusier reportedly gave the advice "don't pave the driveway." Le Corbusier believed that forcing drivers to

Exterior shot of architect Paul Weidlinger's summer home that sat on stilts in Wellfleet.
Photo by Madeliene Weidlinger-Friedli.

proceed slowly would allow them to take in the precious transition of the landscape, so Weidlinger left his driveway a narrow, bumpy dirt path that winded from the main road through the woods to his lot. Weidlinger's home in the Wellfleet woods sat on stilts, barely making an impact on the land. Inside, the house centered on one large, open room with walls of glass that opened onto a wraparound balcony with an overhanging roof that spoke to the desire for indoor-outdoor living and kept the house cool in summertime.

The large, open living space that Weidlinger's cottage centered upon. *Photo by Madeliene Weidlinger-Friedli.*

NATHANIEL SALTONSTALL AND OLIVER MORTON

Among the commissions Boston-based architects Nathaniel Saltonstall and Oliver Morton designed was the first Institute of Contemporary Art building (Saltonstall was a founder and president of the museum from 1936 to 1948). The partners began designing projects on the Outer Cape in the 1940s. The most notable of their works was the Colony (originally called the May Hill Colony Club), a complex of multiple Bauhaus-inspired units that housed artists who were invited to exhibit their work

and the patrons who were invited to buy it. The flat-roofed cottages, set among the sandy, pine-studded hillside of Chequessett Neck, were arranged in a meandering circle clustered around a communal gallery. It was an enclave for the elite; guests had to have social and banking references to stay there. Over the years, guests included writers Bernard Malamud and William Shirer; actors Paul Newman and Faye Dunaway; publisher Alfred Knopf Jr.; and numerous other intellectuals, professors and artists. While visitors may have been elite, the accommodations were far from it. Cottages were small and sparse, mostly one-bedroom, one-bath units with galley kitchens and rooms laid out along a straight line. Furnishings were Spartan but clean-lined and designed by leading Modernists of the day, floors were made of concrete and terraces and expansive windows embraced the landscape. Saltonstall was a prodigious art collector; original artwork hung in the cottages, while frescoes and sculptures decorated the outdoors.

The Colony still exists, though its doors are now open to all interested comers. Measures have been taken to ensure that cottages remain in their original exterior condition, and the interiors are still very much Bauhaus spaces, featuring minimalist décors with modern pieces, including Eames tables and chairs, wall-mounted desks and narrow beds that serve as couches during the day.

Olav Hammarstrom

Another esteemed European architect who found the Cape to be fertile ground for experimentation was Olav Hammarstrom. After arriving in Boston during the late 1940s from Finland, he went on to work with Eero Saarinen, Gropius's firm, the Architects' Collaborative, and also had a private practice. He married Marianne Strengell, one of the twentieth century's most influential textile designers, who executed many commissions for Hammarstrom, Breuer and Saarinen, including all of the textiles for the General Motors Technical Center. In 1952, Hammarstrom designed a cottage for himself and Strengell in Wellfleet. The house was built in two sections; one was insulated and

enclosed, containing the bedrooms and kitchen. The other was a warm weather section, containing summer dining and living areas that could be opened entirely to the elements by means of two large barn doors on tracks. Based on his own cottage, Hammarstrom received several other residential commissions in the area, including one for MIT physics professor Laszlo Tisza.

CHARLES ZEHNDER

Perhaps the most prolific modern architect on the Cape was Charles Zehnder, who built more than forty-five homes from the 1950s through the 1970s. A graduate of the Rhode Island School of Design who became a year-round Wellfleet resident, Zehnder's early designs were inspired by Frank Lloyd Wright's Usonian houses. His later works were inspired by a range of aesthetics, including Thomas Jefferson's Paladianism, Mies van der Rohe's unified and simple geometric forms and World War II bunkers.

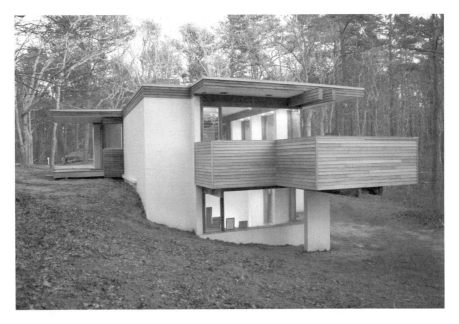

The Charles Zehnder–designed Kugel-Gips house, open to the public. *Courtesy of the Cape Cod Modern House Trust.*

By the late 1970s, Zehnder was experimenting with poured concrete, completing four crystalline residences that also featured cantilevered wood deck structures. A noted Zehnder design is the Kugel-Gips House, located on a hill in a sparse forest overlooking a serene pond. The design exhibited long horizontal lines and a narrow base and combined wood with concrete and glass; exterior materials, such as clapboards, were also used indoors. The flat-roof house had two elevations that were bunker-like in their use of concrete blocks and oblique windows. Facing south and west, however, ribbons of glass ran the length of each wall, and corners featured butt-glazed windows. Long, cantilevered decks and roof overhangs projected the living space into the landscape.

PRESENT-DAY STATUS

Over the decades, many of the Outer Cape's mid-century Modernist dwellings have suffered neglect. Others have been razed, casualties of skyrocketing real estate prices that have made land far more valuable than the houses. Still, remarkably, more than eighty Modernist cottages remain throughout the Outer Cape.

While the majority of these structures are privately owned, five located within the Cape Cod National Seashore are owned by the National Park Service. In dire need of attention, the cottages were slated for demolition not too long ago. However, thanks to architect Peter McMahon, executive director of the Cape Cod Modern House Trust, it seems the cottages are on the verge of being saved.

The reason the cottages within the National Seashore were threatened goes back to September 1959, when a bill calling for the creation of the Cape Cod National Seashore was introduced in Congress and signed into law two years later. In those two years, rumors circulated about the terms of legislation, particularly whether new construction would be allowed on undeveloped land and whether there would be a cutoff date for such construction. From 1959 to 1961, 120 houses were built within the National Seashore. Congress eventually made the date of the bill's introduction the cutoff date for construction, and all of those houses

were deemed illegal. The National Park Service acquired the houses by eminent domain, and most owners sold to the government or negotiated a sale that guaranteed them life use of the property or twenty-five-year leases, which have all now expired.

The five mid-century Modernist cottages were among several structures built in the park during those pivotal years slated for demolition in the late 1990s. At the time, the National Park Service met with the Massachusetts Historical Commission, and no one considered the Modernist cottages to be of architectural importance. So the National Park Service planned to tear them down. As they were not a top priority, demolition wasn't immediate, yet the cottages sat vacant, which led to deterioration. Wood rotted, mold became rampant, rain and animals found their way in.

A crusade for the preservation of the Outer Cape's Modernist architecture began about 2002 and gained steam in 2006, when McMahon co-curated an exhibit on the subject at PAAM (Provincetown Art Association and Museum). About this time, the National Park Service met again with the Massachusetts Historical Commission about tearing down the cottages, and they were informed that five Modernist cottages were now deemed eligible for the National Register. Although they are less than fifty years old, they are considered significant on both local and state levels because they are unaltered specimens of the Modernist architectural phenomenon that transformed postwar America.

Unfortunately, the National Park Service, which owns seventy historic properties within the National Seashore, does not have the budget to care for the houses. That's where McMahon comes in. Since 2006, on behalf of the Cape Cod Modern House Trust, he has been working with the National Park Service to develop a lease for the long-term preservation and use of the Zehnder-designed Kugel-Gips House; in 2009, he obtained the lease. McMahon received a $100,000 grant from the Town of Wellfleet toward the restoration of the Kugel-Gips House and garnered about $40,000 in volunteer pledges to do work on the ailing structure. Restoration of the cottage began in earnest during the summer of 2009. The work centered on restoring the home to its original condition, not "modernizing" it according to present-day standards. Mold issues were dealt with, rotting wood was replaced and the roof was redone. There

were few updates in the bathrooms and kitchen, which have had the same fixtures since the house was built. "These houses were built for simplicity, and that's what makes them so beautiful," says McMahon. The décor consists of mid-century Modernist furnishings, including pieces by Bertoia, Saarinen and Bellini. The home's purpose is to serve as an educational facility to educate the public about Modernism. It is a cultural resource open for tours, academic retreats and a scholar-in-residence program. To help defray costs, the three-bedroom, two-bath house is available for rent to individuals and corporations several weeks a year.

The Cape Cod Modern House Trust is currently in the process of obtaining a lease to restore the Hatch cottage, which has been in a rapid state of decline since Ruth Hatch, who inhabited the home seasonally until her death in 2007, passed away. As with the Kugel-Gips House, the Town of Wellfleet has pledged $100,000 toward the restoration of the cottage. The Cape Cod Modern House Trust does not have the means to restore all of the endangered Modernist cottages, which include the Weidlinger House; the Kuhn House, designed by Saltonstall and Morton; and a Hammarstrom design, the Tisza House. But it is the organization's hope that its efforts will be recognized by others who will treat the cottages as the historic specimens they are.

Modernism in Falmouth

Aside from the extensive group of Modernist cottages built on the Outer Cape, there were few built throughout the rest of Cape Cod. Yet the town of Falmouth was the setting for a smattering of early Modernist homes. The architect responsible for the homes was MIT-educated E. Gunnar Peterson, who had lived in Falmouth since childhood. His designs began dotting the landscape in the late 1930s. Of slightly more sturdy construction than the cottages on the Outer Cape—most of which were only equipped for summer living—Peterson's houses were insulated and had radiant heat, with basic wood exteriors and flat roofs. Floor plans consisted of two or three bedrooms, and houses featured

glass-enclosed rooms, cantilevered decks and merged dining and living rooms with smaller kitchens and the cost-cutting elimination of cellars and attics. Peterson's one-level houses, most of which included garages or carports, cost between $7,000 and $12,000. Structures were intended to give the illusion of spaciousness, of much more with much less, and this was achieved by creating large glass areas to bring the outdoors inside, making the view part of the actual living space. Peterson's vision was that not only should the house be part of its site and terrain, but that the inside, the area of family use, should count for more than exterior impressiveness fashioned for the eyes of neighbors.

In 1940, Peterson, who designed more than twenty-five residences in the area throughout his career, was responsible for the Cape's first planned Modernist development, along the beach on Bywater Court in Falmouth. His creations defied the town's architectural traditions so hard and often that he kept a scrapbook to find out which particular controversy was raging at the time. The cottages on Bywater Court, which were featured in the magazine *Progressive Architecture* in 1941, provided a sharp visual contrast to what was familiar to Falmouth. The town had strong negative reactions to the development, and several business owners went to town meeting to express their fears that the houses would cause a diminution of the town's local color and would result in a decrease in tourist income. Local newspapers applied the most horrendous epithet one Cape Codder could apply to another at the time: they termed Peterson *almost* a native.

Unfortunately, Peterson's Modernist designs never quite received the recognition that they deserved. While some of his creations continue to exist in Falmouth, of the ten houses on Bywater Court—which should have been lauded for their architectural ingenuity, as other planned Modern neighborhoods in the state have been, such as Lexington's Six Moon Hill—only a few exist in their original incarnation. Some have been torn down, and others have been renovated into two-story, shingle-sided homes that bear little resemblance to Peterson's inspired designs.

Chapter 7

HOUSES OF CONTEMPORARY TIMES

RESIDENCES OF THE 1950s–1970s

By the second half of the twentieth century, the Cape's population was increasingly expanding. While the summer population predominated most towns, the area was home to a significant number of year-round residents, and most houses were constructed for year-round use. An article in the August 1950 issue of *Holiday* magazine titled "Cape Cod's New Cottages" describes the residences that were being built throughout the region at the time.

The article, authored by Carl Biemiller, depicts the Cape:

> *Geographically the Cape is small. No town is too far distant for a morning's drive. Still, it owns an illusion of size due to the hundreds of side lanes which deviate from main highways and lead into pond-edge or bayside retreats. Entirely embraced by the sea, the Cape is warmer in winter than the mainland, with only a third as much snow as Boston. Springtime comes cool and late and garnished with rolling salt fogs and heavy mists. Midsummer days are hot with a crystalline quality that would fool a man with myopia into thinking he could see for ten miles… The autumn months, best of all in "native" judgement are dry and warm…Winter winds whip from the northwest in November, an icy*

change from the southwest winds which blow three out of five days the rest of the year at rates ranging from twelve to twenty-five miles an hour.

As always, Cape winds and weather influenced house design in the latter half of the twentieth century. Homeowners created gardens that were half covered to protect from the elements. Plate-glass windows, which could fall prey to etching in certain breezes, were placed where sand couldn't get to them at ground-level sills. Houses very close to the water were placed on stilts so that high water, carefully computed for abnormal flood levels, could not enter the living quarters. Building materials were selected to resist dampness and corrosion. Massive fireplaces served as anchors and were a well-defined part of the newer Cape homes. Usually located away from windows, in many cases open on both sides with double hearths, the fireplace was frequently used as a separation between rooms.

Like the earliest Cape Cod–style houses that were shingled and allowed to weather silvery gray in color because of the abrasion that the salty air and sea winds caused, newer houses duplicated the technique. Otherwise, constant painting would be required to maintain a home's exterior color, a costly and time-consuming endeavor. If homeowners did opt to paint their homes, the most common choice was a basic white, which was relatively cheaper than other colors. Houses trended toward informality that complimented the region's laidback atmosphere; they were cheerful, light and open.

Biemiller wrote:

Most Cape residents prefer to take their color from the landscape with the "big view" as part of the house. Thus expansion glass areas are common. Openness is the key to house design and a variation of techniques is used to achieve it. There is wide use of skylights on both pitched and flat roofs. Clerestory windows (openings placed above eye level) spill light into hallways and entrance areas. Rooms themselves, although clearly identified units, have fewer wall partitions and more windows.

While ground-floor bedrooms with large windows or glass walls contributed to the outdoor illusion and may have seemed expansive, in the 1950s, 1960s and 1970s, most bedrooms tended to be small, without much space for sitting or dressing room arrangements, and closets were also small. They were in keeping with the informal way of life that architecture of the era was seeking to express. Similarly, bathrooms were compact, conventional and sparsely decorated. The baths were augmented by outdoor "shower rooms," generally accessible from a terrace or a garden approach to a house. Kitchens were often located next to a terrace or adjacent to a screened porch and were equipped with the time period's modern refinements, including pass pantries and bars that doubled as breakfast counters. "Because the trend is away from house servants most kitchens are loaded with step saving, built-in gadgetry, ranging from automatic dishwashers to wall-embedded refrigerators. Some kitchens, thoughtfully planned, double as workrooms and living area in which function they are returning to the traditions of the classic Cape Cod cottages where the kitchen was used as the center of family life," wrote Biemiller.

Rooflines tended to vary during this period, and there was great debate about whether flat or pitched roofs were more efficient. While flat roofs were known to weather well and handle the Cape snowfalls with ease, the pitched roof was considered to do a great deal to increase the feeling of spaciousness in the interior as well as to offer variety and interest to small rooms.

Widely impressed by both the region and the newly constructed houses he toured on Cape Cod, Biemiller wrote:

> *Modern or conventional, the holiday house on the Cape is likely to be a retreat tucked among the trees with its back to main highways, or a sun-sprinkled edifice on a jut of sand reaching to the sea. It offers a thrilling, fall-away view of a tree-cloistered pond or a horizon sight of ocean. Simple enough in appearance from the outside it is carefully zoned for the maximum family comfort. Houses have moods and the atmosphere of the Cape house is one of untroubled security close to nature, but taking advantage of every possible mechanical blessing.*

The Influence of Past Styles on Present-day Architecture

While not nearly as publicized as the broad beaches and serene salt marshes, the array of house styles is considered by many to be one of the Cape's particular attributes, says Sara Porter, an architect who practices in Yarmouthport.

I think one of the reasons people are attracted to this area is because of the diversity of the existing architecture. It is unique to have the range of house styles that are found here. Cape-style houses have been being built since the 1600s, and while each one is based on that symmetrical one-and-a-half-story design, the different centuries have influenced the design in some way. Those built in 1780 might depict Georgian influence, others built in the early nineteenth century typically have hallmarks of Greek Revival design and then you'll see Capes with Gothic Revival porches or Italianate arched windows. Just like we do today, people would change their houses, add details that were popular at the time that they were drawn to. The layering of styles is really very interesting around here.

When it comes to houses constructed in recent decades, Porter, who takes the lead from historic styles in her designs, says: "Certainly how we live is different, but historic elements have become part of the norm of present-day residential architecture." Today's architectural styles look to the past, featuring forms and volumes, window styles, trim details and rooflines that may have been slightly modified or reinterpreted but are relatively the same as they were in past centuries.

John DaSilva, principal of Polhemus DaSilva Architects Builders in Chatham, agrees that most of today's houses are variations of past styles.

The Cape is still a very popular house type. It was born out of necessity—the need to hunker down and ride out storms along with the economically driven need for efficient and inexpensive construction. Except for brief periods in limited locales, Cape Cod has never been

a particularly wealthy region. Its building transitions evolved out of an economy of scarcity rather than plenty. The Cape house type was low to the ground, easy to build with a minimum of skilled labor and efficiently laid out to maximize flexibility in use of space, materials and heat. Economy is still a factor in some people's decisions to build Capes today, but romantic and nostalgic ideas are also prevalent.

Polhemus DaSilva Architects Builders designed and built the contemporary Cape pictured here to satisfy both a romantic attachment to the historic house type and a functional need for a sizeable house. The tall gambrel roof crowns three floors of living space. The back of the house is whimsically detailed; it explodes into a three-story pile that stretches up to capture water views and that elegantly evokes soaring sea gull's wings or crashing waves of the ocean context.

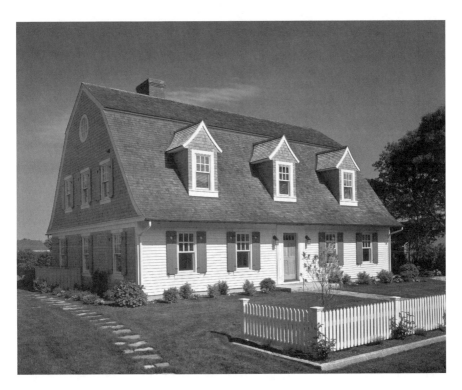

A contemporary Cape Cod–style house with a tall gambrel roof that crowns three floors of living space. *Photograph by Randall Perry. Courtesy of Polhemus DaSilva Architects Builders.*

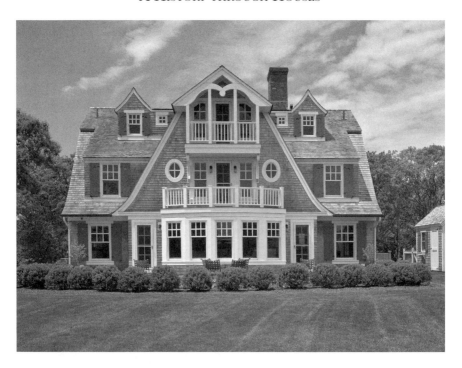

The whimsically detailed back of the house has a storybook quality to it. *Photograph by Randall Perry. Courtesy of Polhemus DaSilva Architects Builders.*

DaSilva notes that the strongest influence from the past is the symbolic Cape Cod–style house but points out that the Shingle style is also frequently emulated in current designs and has become somewhat of a local vernacular. Greek Revival and Gothic Revival traits are also commonly incorporated into new houses. "We design houses that are influenced by all of these styles [along with Georgians, Italianates and bungalows], but they are not literal re-creations of these," says DaSilva. The house pictured here, located on a lake and designed by DaSilva's firm, combines the hipped roof/big overhangs/horizontal reach of classic summer camp bungalows with the pointed arches of the Gothic Revival. "The interior stairway is dramatic yet fun. Here the Gothic of the house's front porch gives way to even more eclectic references inside," says DaSilva. "The flat columns and balusters evoke Baroque architecture, or ropes, or child's drawings or…but all in a playful way befitting an active family seeking playtime at their lakeside retreat."

Houses of Contemporary Times

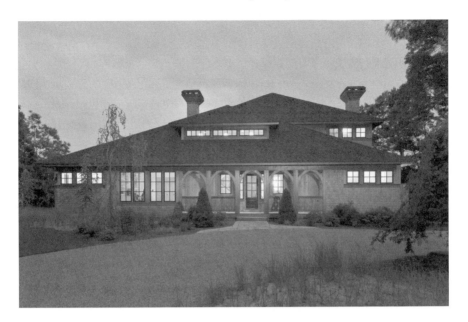

Above: This lakeside house integrates bungalow style with Gothic Revival. *Photograph by Randall Perry. Courtesy of Polhemus DaSilva Architects Builders.*

Right: Inside, flat columns and balusters evoke Baroque architecture. *Photograph by Randall Perry. Courtesy of Polhemus DaSilva Architects Builders.*

While Modernist-inspired houses continue to be built throughout the Cape, they are not the norm. In recent years, most people building on the Cape want houses that look relatively traditional on the outside. The interiors, however, have made steady transitions. "Early on, the primary consideration in building houses was to shelter you from the weather. That's changed quite a bit. We want more light, more windows, more open floor plans that combine the kitchen, dining area and family room," says Porter. "My clients want more bedrooms and bathrooms for extended family and guests, more attention to space for outdoor living and ample storage space."

While houses on Cape Cod were originally built in protected areas, in valleys or town where protection was afforded, rather than exposed on hilltops or on the beach, that has significantly changed over time. "When the economy changed to a tourism base, people came here to experience the landscape and seascape, and they located their houses to take advantage of nature as it came to be seen as an asset rather than a liability. This is still the case today," says DaSilva. Views are highly coveted in homes built now. "Water view land here is so expensive that if you're fortunate to have access to it, it's a given that a house will be designed to maximize views," he adds. One of DaSilva's designs, a contemporary version of the Shingle style with a classic "umbrella gambrel" roof shape (a gambrel that flares out at it eaves), is a traditional beach house with a fresh attitude. The house nestles into the dunes and is shaped so the lines of the rolling landscape and seascape are reflected in the rolling roofscape. From the beach, the house has more roof than walls. An eclectic take on the Shingle style is DaSilva's own home, which features combined English cottage architecture and Bay-area Shingle style to create a quirky yet urbane house. The rich brown, orange and black color scheme is cheerful year-round for a family home, versus the typical gray and white most associated with vernacular buildings in the intense Cape Cod summer sun.

During the 1970s, Porter says that there was a lot of momentum to build sustainable structures, and while that had fizzled by the mid-1980s, there is now a great deal of talk about incorporating green technologies into new houses in the area. "People are interested in solar technologies

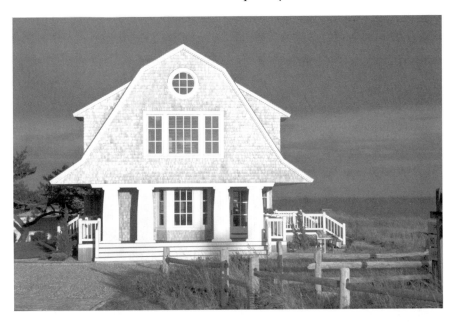

A contemporary version of a classic Shingle-style home on the beach. *Photograph by Randall Perry. Courtesy of Polhemus DaSilva Architects Builders.*

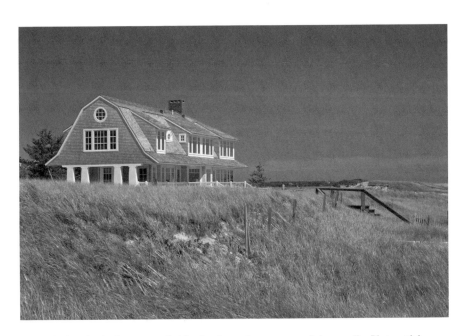

From the beach, the house, nestled in the dunes, has more roof than walls. *Photograph by Randall Perry. Courtesy of Polhemus DaSilva Architects Builders.*

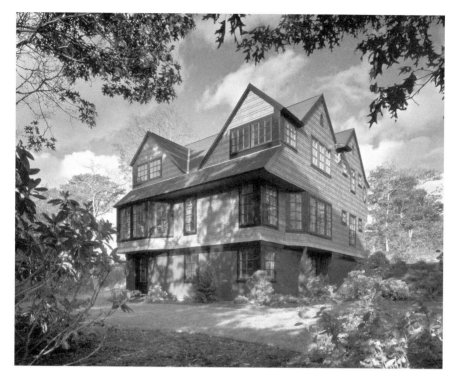

Incomplete forms, like partial dormers and bay windows, characterize this contemporary home that combines English cottage architecture and Bay-area Shingle style. *Photograph by Paul Rocheleau. Courtesy of Polhemus DaSilva Architects Builders.*

and geothermal systems. The state has become more stringent about energy requirements. In addition, new construction must comply with strict wind impact rules, which requires a lot of structural elements that necessitate lengthy reviews by engineers," she says. While the Cape's zoning regulations are strict and getting the necessary permits can sometimes be an arduous process, people building houses are becoming interested in using the Cape's forceful winds to their benefit by building wind turbines on their properties.

Porter says:

> *The future of architecture will likely continue demonstrating affection for the past while incorporating innovative elements and materials. There are more man-made materials, more efficient windows and*

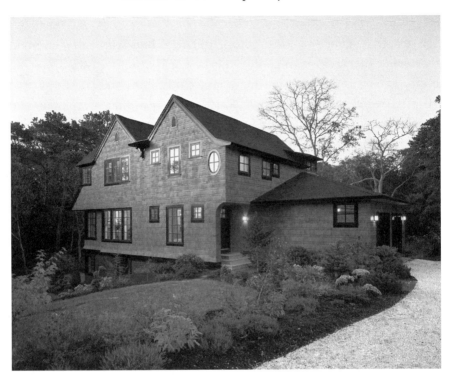

The rich brown, orange and black color scheme is a contrast to the typical gray and white most commonly associated with residential architecture on Cape Cod. *Photograph by Paul Rocheleau. Courtesy of Polhemus DaSilva Architects Builders.*

heating systems and high-tech accommodations for the computer, TV, telecommunication and sound systems. People hope to design homes that are compatible with the natural surroundings and existing architectural styles, demonstrating a respect for and interest in history. Their homes reflect an increasing need for convenience and comfort while trying to preserve the quality of life on Cape Cod.

PRESERVING HISTORIC HOUSES

Preservationists have made great strides to protect the area's historic structures. Countless structures on Cape Cod are listed on the National Register of Historic Places, and exterior alterations of historic properties

are strictly regulated by local historic districts. The districts also require the review of new construction projects. Local historic districts play an important role in preserving the distinct neighborhoods of the Cape. Historic district commissions, charged with reviewing developmental proposals within the districts, face increasing opposition. According to the Cape Cod Commission website,

> To help ease the process, detailed guidelines direct the reviews and commissions work with town planning departments, zoning enforcement officers, and the Cape Cod Commission—the Cape's regional planning and regulatory authority—to ensure consistency of their goals and regulations.
>
> Over the years, as new development increased in the area, many distinctive cultural landscapes, which define the boundaries between village centers and reflect the region's architectural heritage disappeared.

The Cape Cod Commission was formed in 1990 to develop conservation restrictions that seek to protect historic landscapes and properties from further disintegration. The website states:

> In many cases, demolition-delay bylaws, which provide an opportunity to consider alternatives to demolition of an historic property, have been effective. Eleven Cape towns have passed demolition-delay bylaws and most of them provide for at least a six-month delay, discourage demolition by neglect, and require new development plans to be approved by all town boards before a demolition permit is issued. In highly desirable locations, unfortunately, the pressure to demolish historic properties continues to be high, as many individuals desire to build larger, more contemporary structures that capitalize on views.
>
> Preservation restrictions—deed restrictions that require preservation of a building's historic exterior features—have been useful in protecting important historic properties.

For example, the Old King's Highway is considered to be one of the largest designated historic districts in the country, as well as one of

the oldest. Beginning in Bourne, it crosses through the communities of Barnstable, Yarmouth, Dennis, Brewster and Orleans. The Old King's Highway Regional Historic District Commission was established in 1973 to protect from the intrusion of large or unsightly signs, unattractive or view-blocking fences and the construction of new homes, sheds and garages that might be inappropriate or incongruous with the existing historic structures. Town committees of elected volunteers review all proposed exterior changes to houses in the district. Their review includes exterior design, colors, window and door types, signs and lighting.

The Cape Cod Commission requires encouragement of the appropriate reuse of existing historic structures, and in some cases, antique buildings have been moved to sites where they may be better utilized and appreciated. According to the commission's website:

The Cape Cod Commission mandates that alterations should be accommodated in a manner consistent with the properties' essential historic elements and patterns of change over time. However, the organization is sensitive to the progress of the present day and typically allows for appropriate changes to accommodate new uses and technologies that will help promote the reuse of historic properties and ultimately encourage their preservation.

The Cape Cod Commission's review of historic properties focuses on allowing for "rehabilitation" as defined by the US Secretary of the Interior's Standards for Treatment of Historic Properties. So defined, rehabilitation is "the act or process of making possible a compatible use for a property through repair, alterations, and additions while preserving those portions or features that convey its historical, cultural, or architectural values." When it comes to new development adjacent to or within Cape historic districts or historic properties, new structures are required to be designed consistently with the character of the area and to retain distinct features of the neighborhood. Elements of the distinctive area's character such as building mass, height, scale, roof shape, roof pitch, building materials, and proportion between doors and windows must be maintained.

While DaSilva is a great supporter of historic architecture, he is careful to note that his passion for preservation has limits. He says:

> *I do not use a "preservation" attitude to reject or deny change…Change in past eras is what has made the built environment here so desirable. We would not, for example, have the Chatham Depot if Victorians were disallowed long ago. We would not have the Eldredge Public Library if Richardsonian Romanesque were disallowed. These are two beautiful and beloved pieces of architecture, but they are dramatically different from what came before them. To this day there are historic review boards in our region that reject these buildings because they would be "out of character" with their neighbors.*

"I am a preservationist in the sense that I believe buildings that are of high architectural quality, that have valid cultural significance and that create the fabric of village centers should be preserved," he says, while cautioning that we must take care not to deny change or freeze the built environment into any one era.

Updating Classic Houses for Contemporary Living

One of the main reasons that historic houses are threatened is because of the high cost of restoration. Equipping them with systems that meet modern requirements and simply stabilizing some of the more deteriorated structures can be an exhaustive process. DaSilva says:

> *It's tricky to update an historic house. If done well, it is generally more expensive to save and restore an old house than it is to build a new one. It takes a commitment from the owners to choose materials and details that are historically appropriate. Contemporary regulations require upgrading structure, stair dimensions, railing heights, head room, fireplace dimensions, insulation, heating and cooling systems, etc. to meet current building and energy codes.*

He does point out, however, that many local building officials are somewhat flexible when it comes to antique houses.

Clients who want low-maintenance materials will most often find that they are not easily incorporated into historic homes. For example, while historic houses on the Cape always had wood window frames and sash, DaSilva says most of today's homeowners want aluminum- or vinyl-clad windows because they do not have to be regularly repainted. They are also less expensive when the labor to paint them is taken into account. He points out:

> *The problem is that aluminum- or vinyl-clad windows are detailed very differently than traditional wood windows. They sit in the wall differently—with their faces designed to be flush with or extending beyond the casing trim rather than behind the casing trim. This significantly changes the way shadow lines are cast around the windows…With stimulated divided lights, the muntin bars overlap the glass, and there is a shiny aluminum spacer bar between the two panes of glass. From an angle the aluminum is visible through the glass, especially when the sun is at an angle and reflections are bright.*

From the exterior it is noticeable that the windows aren't part of the home's original design. While maintenance can be a big issue when it comes to wood frame windows on historic houses—screens and storm windows have to be removed and stored seasonally and repainted regularly—the authentic windows add great appeal to the character of the house.

While the costs and effort required to overhaul a historic house may be steep, Porter contends that it is possible to make one suitable for contemporary lifestyles without compromising its integrity or breaking the bank. "By looking at the exterior of a house, you often don't know what's going on inside," she says, explaining that in many cases owners opt, and are required to if they are located in historic districts, to keep the front façade intact. "Rooms are smaller in the older houses, and surprisingly, many people actually don't mind that. In favor of historic preservation they'll keep the front rooms intact and create an addition to

the back of the house that isn't visible from the street." On back additions, homeowners can accommodate modern living by creating large, open areas with big kitchens and rooms that revolve around family living. Large windows and spacious first-floor master suites are typically part of renovations to older houses, she adds, pointing out that homeowners may spend little time in the home's original front rooms, choosing to do most their living in the new family-centric spaces.

"Living in an old house is about making compromises," says Porter. "But that's part of the charm."

Chapter 8

WHERE TO GO

The majority of Cape Cod's historic architecture is available for the average passerby to enjoy. You will discover houses of the past simply by ambling along the region's scenic roads and byways. Not knowing what you will come upon—where you will encounter a rickety seventeenth-century Cape Cod, a rambling antique Shingle style summer mansion or a flat-roofed roofed Modernist retreat—can often make for a great adventure. However, if you would like guidance for your historic house hunt, here's insight to some areas where you will encounter particular styles and information about houses that are open to the public.

CAPE COD STYLE

A treasured eighteenth-century full Cape Cod–style house open for tours is the **Atwood House** in Chatham. Operated as a museum by the Chatham Historical Society, the bowed-roofed house has been restored and furnished to reflect several periods. The house has an intact keeping room, a borning room and a large open attic with a fireplace. In addition to period artifacts, the house features a gallery of sea captains' portraits, an extensive textile collection and a permanent fishing exhibit that highlights the commercial fishing industry. The museum also showcases

changing exhibits seasonally. 347 Stage Harbor Road, Chatham; www.chathamhistoricalsociety.org; (508) 945-2493.

You will find more historic Capes, along with the Greek Revivals, Georgians and a few Italianate, Victorian and Gothic Revival houses, along Route 6A, known as the **Old King's Highway**, which parallels the shores of Cape Cod Bay for thirty-four miles, crossing through the communities of Bourne, Sandwich, Barnstable, Yarmouth, Dennis, Brewster and Orleans. The Old King's Highway meanders along cranberry bogs, salt marshes and ancient burial grounds and winds past hundreds of historic structures that characterize its early development. The route is believed to have evolved from Native American trails that stretched from Plymouth to Provincetown. As colonial agricultural settlement increased on the Cape, the cart path became a major east–west thoroughfare for early settlers. The narrow road became an extension of the "King's Highway" in the late seventeenth century. With the rise of maritime activities, sea captains' homes began to develop along the route, and stagecoaches took the highway on the way from Boston to Provincetown. As horse-drawn carriages were replaced with automobiles, the road continued to evolve by paving and constructions of bypasses through wetlands that were skirted by the original roadway. Despite the road's modifications, it follows the original seventeenth-century footprint in most sections.

Early Georgian

The **Winslow Crocker House** is a shining example of an Early Georgian classic. Originally constructed in 1780 in Barnstable, the house was moved to Yarmouthport in 1936 by Mary Thatcher, an avid collector of antiques, to display her collection. Now a museum run by Historic New England, the elegantly symmetrical two-story home has twelve-over-twelve small-pane windows and rich paneling in every room. In addition to being a truly restored specimen of historic architecture, the house features Thatcher's vast collection of early American furniture, including Jacobean, William and Mary, Queen Anne and Chippendale.

The furniture is accented by colorful hooked rugs, ceramics and pewter. 250 Main Street (Route 6A), Yarmouthport; www.historicnewengland. org; (617) 227-3956.

The **Daniel Davis House** contains the collection of the Barnstable Historical Society. Built in the mid-eighteenth century, the post-and-beam Early Georgian residence was built for Davis's bride, Mehitable Lothrop. A venerable Barnstable resident, Davis, a judge, was a town selectman, a delegate to the first three Provincial Congresses and a militia captain. The house has ten exhibit rooms, which have been remarkably well preserved to reflect the eighteenth and nineteenth centuries. An ell was added to the original house in the 1880s. Among the array of exhibits, you will find eighteenth- and nineteenth-century furniture, china, glassware, portraits, ship models, tools, toys and Native American artifacts. 3074 Main Street (Route 6A), Barnstable Village; (508) 362-2982.

MIDDLE GEORGIAN

Built in 1794, Falmouth's **Julia Wood House** was once the most gracious in town. The treasured Middle Georgian–style home features a hip roof, twin chimneys, a widow's walk and a two-story open porch. Built for Dr. Francis Wicks, a leading American pioneer in the use of smallpox vaccines, the home features an eighteenth-century doctor's office, along with rooms restored to their original condition. Owned by the Falmouth Historical Society, the Julia Wood House and the Conant House, another eighteenth-century residence next door, are known as the Museums on the Green, as they overlook the Village Green, where members of the colonial militia practiced in the 1700s and sea captains built their homes. Both museums showcase period furnishings, china, toys, vintage clothing, fine art and handmade quilts. Special exhibits depict Falmouth's nineteenth-century maritime industries and the life of Katharine Lee Bates, Falmouth-born author of "America the Beautiful." Completing the complex is the recently rebuilt Hallet Barn, a hand-pegged structure above grade with a basement housing a new climate-controlled curatorial work and storage area. The exhibit area of

the barn features old tools and equipment for domestic chores, hands-on educational activities and period clothing. 55 and 65 Palmer Avenue, Falmouth; www.falmouthhistoricalsociety.org; (508) 548-4857.

Greek Revival

The **Captain Bangs Hallet House**, an impressive Greek Revival with a Doric-columned front porch, pays homage to the whaling captain who inhabited it for thirty years. A museum operated by the Historical Society of Old Yarmouth, the home is furnished in the nineteenth-century style of a typical sea captain of the era. At the foot of the canopied maple bed in the master bedroom you'll find a leather-bound chest Hallet's wife Anna took when she accompanied him on his voyages. The parlors are arranged as if the captain was just returning from an excursion to China or India, and the beautifully proportioned rooms are filled with the finest furnishings of the day, from Hitchcock chairs to a Hepplewhite sofa. 11 Strawberry Lane, Yarmouthport; www.hsoy.org; (508) 362-3021.

Yarmouth Captains Mile

To see more examples of sea captains' homes, watch for the black and gold plaques on the front of fifty-three homes along Route 6A in Yarmouthport, where more than 330 sea captains made their home through the eighteenth and nineteenth centuries. The most famous of the captains is the colorful Captain Asa Eldridge, who set a record sailing the *Red Jacket* from New York City to Liverpool, England, in just thirteen days and one hour. Another notable captain was Captain Nathan Hallet, born in 1797 and one of the earliest packet masters. His house is one of the oldest houses in Yarmouth. A self-guiding map is distributed widely throughout Yarmouth and neighboring towns at local shops, restaurants and libraries. They are also available at the Historical Society of Old Yarmouth headquarters just outside of the Captain Bangs Hallet House. 11 Strawberry Lane, Yarmouthport; www.hsoy.org; (508) 362-3021.

SECOND EMPIRE

One of the most unique homes on Cape Cod is the 1868 **Captain Edward Penniman House** in Eastham. The former residence of one of New England's most successful whalers, the house was among the most extravagant of its era. With a colorful exterior paint scheme of yellow, white, black, green, brown and red, at the time it was built the house featured state-of-the-art home technology and was furnished with items Penniman collected on his far-flung voyages. The exterior retains its original appearance, and the interior has been remarkably well preserved to reflect the same aesthetic as when Penniman and his family resided there. All of the woodwork, finishes, hardware and wall and ceiling coverings have survived. Located within the boundaries of the National Seashore, the house is operated as a museum by the National Park Service. Along with original furnishings, contents of the house include Penniman's written records, letters, diaries, journals and family photographs. Fort Hill Road, Eastham; www.nps.gov/caco; (508) 255-3421.

CARPENTER GOTHIC

To see examples of the whimsical cottages that Methodist camp-goers built, the **Craigville Campground** still exists as a meeting camp preserve and conference facility where the Cape Cod Writers Center hosts summer programs. While it isn't possible to tour the interior of cottages, one may stroll past them. 39 Prospect Avenue, Craigville; www.capecodwriterscenter.com; (508) 775-1265.

If you happen to venture over to Martha's Vineyard, **Wesleyan Grove**, owned by the Martha's Vineyard Camp Meeting Association, is a must-see. A National Historic Landmark, the campground continues to host religious and non-secular programs and events. Visitors to the Cottage Museum can view the interior of a typical campground cottage, complete with period furnishings offering a glimpse of life on campgrounds in the 1800s. Also on display are vintage photographs,

along with other interesting documents relating to the history of the campground. There, you will also find information cottages—all of which are privately owned—that are available to rent. 80 Trinity Park, Oak Bluffs; www.mvcma.org; (508) 693-0525.

MANSIONS OF THE GOLDEN AGE

A rare example of Stick style architecture assimilated with Queen Anne, the glorious **Highfield Hall** was constructed as an English-style country manor house for the sons of wealthy Boston retailer James Madison Beebe. Set on a 668-parcel of land overlooking Buzzards Bay on the town of Falmouth's highest hill, the twenty-one-room summer mansion contained a ballroom and a billiard room, sixteen fireplaces and the most high-quality finishes and materials of the era. The exterior was equally ornate and fanciful, as each of the home's four elevations had a different type of projecting bay with different decorative elements. Narrowly rescued from demolition in the 1990s, the house suffered extreme neglect after the Beebes' tenure, including a drastically altered façade. It took nearly a decade to restore the mansion to its original grandeur, but it was well worth the effort. Today, Highfield Hall shines and is open to the community as a cultural center and function facility and for tours. 56 Highfield Drive, Falmouth; www.highfieldhall.org; (508) 495-1878.

Brewster native Albert Crosby, who made his fortune in Chicago, returned home to build a summer haven for his wife in 1887. Known as **Tawasentha**, Crosby's mansion featured elements of Queen Anne style and was a combination of complex gables, dormers, clustered chimneys and broken pediments with Grecian urns on top. The crowning element of the house was sixty-foot-high tower, from which the views of Cape Cod Bay and the inside of the Cape were unrivaled. Built on the plot of land where Crosby had grown up, the modest 1832 Cape Cod–style house of his boyhood was incorporated into the massive structure. The interior living spaces, the center of lavish parties attended by a glittering crowd from artistic and theatrical circles throughout the world, were finished with imported woods and gold leaf. Like Highfield Hall, after

its heyday, Tawasentha suffered a prolonged period of neglect, which led to dereliction. Yet a similar revival effort was also undertaken, and the property has been gradually restored. While there is still work to be done, the elaborately carved tables and rich paneling, marble bathrooms and thirteen fireplaces graced with imported English tile give visitors great perspective of the lavish home's original condition. Crosby Lane, off Route 6A (across from Nickerson State Park), Brewster; (508) 240-2338.

While it isn't possible to visit Grover Cleveland's beloved summer mansion, **Gray Gables**, since it was destroyed in a fire, the railroad station that served his frequent travels to and from Washington, D.C., still exists. Moved to the grounds of the Aptucxet Trading Post Museum in Buzzards Bay, visitors may tour the small station and learn a bit about Cleveland's time in Bourne. 24 Aptucxet Road, Buzzards Bay; www. bournehistoricalsociety.org; (508) 759-8167.

Provincetown Dune Shacks

For glimpses of the dune shacks artists and writers relished during the 1920s, 1930s and 1940s, over-sand vehicles operated by Art's Dune Tours are the way to go. You will travel along the shoreline, where your guide points out the "shacks"—used in the 1800s by the Humane Society in conjunction with lifesaving efforts—where famous artists and writers like Eugene O'Neill and Harry Kemp became inspired to create. 9 Washington Avenue, Provincetown; www.artsdunetours.com; (508) 487-1950.

If you are interested in learning more about the shacks' artist-in-residency programs, contact the Peaked Hill Trust (PHT). PO Box 1705, Provincetown, MA 02657; (508) 487-9507.

Modernist Architecture

While most of the homes designed by Mid-Century Modernist architects on the Outer Cape are difficult to find, as they tend to be located on

hidden dirt roads or nestled in the pines, the Cape Cod Modern House Trust is a great resource that offers information about Modernist retreats that may be open for tours, as well as the Cape's Modernist architecture in general. PO Box 1191, South Wellfleet, MA 02663; www.ccmht.org; (508) 349-3022.

Bibliography

Baisly, Clair. *Cape Cod Architecture.* Orleans, MA: Parnassus Imprints, Inc., 1989.

Booker, Margaret Moore, Rose Gonnella and Patricia Egan Butler. *Sea-Captains' Houses and Rose-Covered Cottages: The Architectural Heritage of Nantucket Island.* New York: iUniverse Publishing, 2003.

Doane, Doris. *A Book of Cape Cod Houses.* Old Greenwich, CT: Chatham Press, 1970.

Gitlin, Jane. *Updating Classic America: Capes.* Newtown, CT: Taunton Press, 2003.

Handy, Edward O. *Barnstable Village, West Barnstable, and Sandy Neck.* Charleston, SC: Arcadia Publishing, 2003.

Morgan, William. *The Abrams Guide to American House Styles.* New York: HNA Books, 2004.

———. *The Cape Cod Cottage.* New York: Princeton Architectural Press, 2006.

Nylander, Jane C. *Windows on the Past: Four Centuries of New England Homes.* Boston: Bulfinch Press, 2000.

O'Connell, James C. *Becoming Cape Cod: Creating a Seaside Resort.* Lebanon, NH: University Press of New England, 2003.

Schuler, Stanley. *The Cape Cod House.* Exton, PA: Schiffer Publishing, 1982.

Sears, Anne, and Nancy Kougeas. *Falmouth.* Charleston, SC: Arcadia Publishing, 2002.

Thoreau, Henry David. *Cape Cod.* Edited by Joseph J. Moldenhauer. Princeton, NJ: Princeton University Press, 1988.

Tolles, Bryant F. *Summer by the Seaside: The Architecture of New England Coastal Resort Hotels, 1820–1950.* Lebanon, NH: University Press of New England, 2008.

Index

A

Airplane House 102
Atwood House 32, 145

B

Beebe, James Madison 82
Biemiller, Carl 129
borning room 26
bowed roofs 31
Boyden, Elbridge 72
Breuer, Marcel 117
buttery 25

C

Cape Cod Modern House Trust
 116, 125, 152
Captain Bangs Hallet House 50,
 148

Captain Edward Penniman House
 55, 149
Carpenter Gothic 61, 64, 72, 149
Chermayeff, Serge 118
Cleveland, Grover 96
Colonial Revival 79
Craigville Campground 68, 149
Crane, Charles R. 102
Crosby, Albert 92

D

Daniel Davis House 147
DaSilva, John 132, 142
dune shacks 108, 110, 111, 151
Dwight, Timothy 19

E

Early Georgian 41, 45, 146
Elmslie, George Grant 102

F

Falmouth Heights 71
Fieldstone Hall 91

G

Gothic Revival 68, 134
Gray Gables 96, 97, 151
Greek Revival 49, 50, 53, 132, 134,
 148

H

Hall, Jack 119
Hammarstrom, Olav 122
Highfield Hall 82, 150
Hopper, Edward 112

J

Julia Wood House 47, 147

K

keeping room 25, 45, 49, 145
Kugel-Gips House 124

M

McMahon, Peter 116, 124
Middle Georgian 47, 147
Millenium Grove 62
Morton, Oliver 121

N

Nickerson, Samuel M. 90
Nye, Albert 81

O

Old King's Highway 140, 146
O'Neill, Eugene 107, 109

P

Penzance Point 87
Peterson, E. Gunnar 126
Phillips, Jack 115
Porter, Sara 132, 143
Prairie style 102
Purcell, William Gray 102

Q

Queen Anne 83, 92, 150

S

Saltonstall, Nathaniel 121
Second Empire 53, 55, 56, 149
Shingle style 89, 136
Stick style 83, 150

T

Tanglewood 85
Tawasentha 92, 150

Thoreau, Henry David 30, 40, 50,
 62, 70, 77, 78, 108

W

Weidlinger, Paul 119
Wesleyan Grove 64, 68, 149
Wheelwright House 89
William Bodfish House 48
Winslow Crocker House 45, 146

Y

Yarmouth Campground 63
Yarmouth Captains Mile 148

Z

Zehnder, Charles 123

ABOUT THE AUTHOR

Jaci Conry has been intrigued by historic architecture since she was a little girl. A former editor for *Forbes*, *South Shore Living* magazine, *Cape Cod* magazine and the *Cape Cod Guide*, she is a Cape Cod native with intimate knowledge of the area's treasured antique homes and was delighted to have the opportunity to write about them for this book. She currently writes about historic homes, architecture and design for publications including the *Boston Globe Magazine*, *Better Homes & Gardens*, *Dwell* and *New England Home*. She lives in a historic 1910 foursquare in Falmouth with her husband, Michael; at the time this book went to press, they were awaiting the birth of their first child. For more information about her work, visit www.jaciconry.com.

Visit us at

www.historypress.net